Painting *from* Life

Douglas Lew

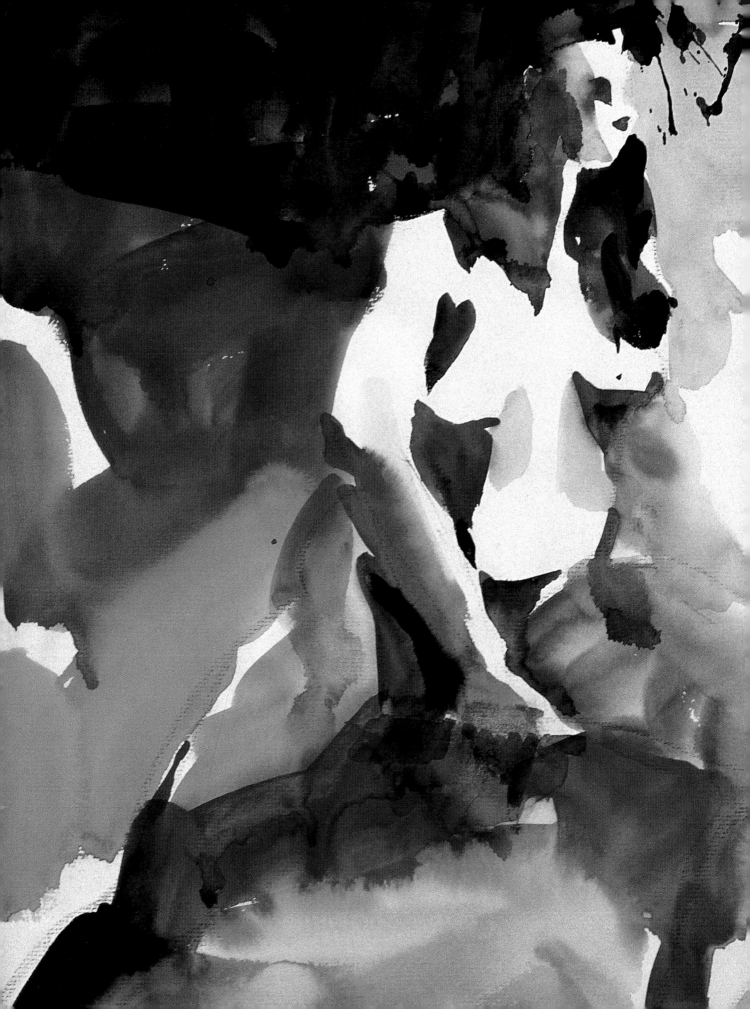

Painting *from* Life

EXPLORATIONS IN WATERCOLOR

Douglas Lew

Watson-Guptill Publications / New York

ACKNOWLEDGMENTS

First of all, I am grateful to Florence Hill who, on a consistent basis, so generously provided her studio and the booking of the models for the co-op, which enabled me to create the work in this book. I am especially indebted to Candace Raney of Watson-Guptill who had the faith and the discriminating foresight to recognize the worth of my effort out of all the figure drawing and painting books already published. This book would not have been possible without her. Lastly, heartfelt thanks go to my editor, Holly Jennings, whose thoroughness and penetrating questions not only straightened my garbled syntax, but also made the book clearer and stronger. In addition, through the collaborative exchange of questions and answers, I also learned something about myself—my weaknesses, my strengths, and the need to always be true to myself. Thanks, Holly.

Library of Congress Cataloging-in-Publication Data
Lew, Douglas.
Painting from life : explorations in watercolor / Douglas Lew.
p. cm.
Includes index.
ISBN 0-8230-3633-2 (alk. paper)
1. Watercolor painting—Technique. 2. Nude in art. 3. Artists' models. I. Title.
ND2190 .L48 2004
751.42'242—dc22
2004004539

Senior Editor: Candace Raney
Editor: Holly Jennings
Design: Eric Baker Design Associates, Inc.
Production Manager: Hector Campbell

Printed in Singapore

FIRST PRINTING 2004

1 2 3 4 5 6 7 8 9/12 11 10 09 08 07 06 05 04

Text set in Pertetua, Caslon, and Gill Sans

TO MY WIFE, LINDA, WHO FOR FOUR YEARS HAS
SO PATIENTLY SUFFERED THE ABSENCE OF ALL
OUR SUNDAY AFTERNOONS AND YET REWARDED ME
WITH ENCOURAGEMENT AND SUSTENANCE

Contents

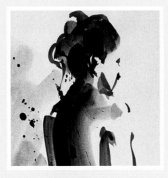

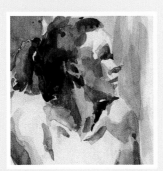

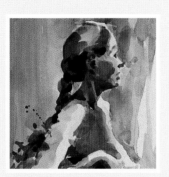

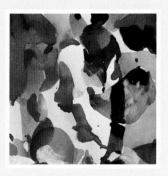

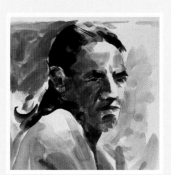

My interest in Douglas Lew's work stems primarily from the rigor of his self-instructional method. Certainly the drawings and paintings in *Painting from Life* are both lovely and moving. They are obviously the product of a talented and mature artistic hand. Yet what I find to be so impressive about this book is the deliberate way in which it builds a case both for understanding and creating artistic compositions.

It seems to me, in this era of over-intellectualized theses, which leads to under-whelming artifacts, that we often lack the skill, commitment, and understanding required to rigorously build a work of art. Intellectual criticism has too often been coupled with a mechanical application of technique to create compositions that are simply one design choice among many, rather than the result of a search for core meaning. In such projects, what you see is truly all you get.

In *Painting from Life* Lew carefully proposes a method in which the hand drawing is reinstated at the center of artistic method. He leads the reader from simple line drawings through washes to build a context for a finished painting. The line drawings that initiate this process search for an intimate sense of the human body as they explore legs, the gentle curve of a back into buttocks, or a hand. Each drawing selects a detail of the body to develop a suggestion of the complexity of the whole to which it belongs. This sense is later probed in shade and shadow, retained in washes, and finally brought to full flower within a contextualized composition. Each simple, yet insightful, line drawing in this book evolves through this carefully laid out procedure to portray more than the visual facts of the human body. And as each line drawing grows to become a painting, the sense of detail becomes progressively more engaging until it expresses what Susanne Langer has termed the "semblance" of our emotional lives.

In some ways, the rigorous method outlined in this book, built over a four-year period, may seem anachronistic in our computerized information age of quick results and innumerable distractions. But in a fundamental sense, Lew's search takes us back to the core of artistic expression. Art is the way in which we explore the complexities of being human. Yet inner complexity remains hidden from a casual view. To render real insight, this exploration must be patient and disciplined.

Lew's process of building compositions provides an admirable model for amateurs and professionals alike who want to undertake such a creative search. This book is a valuable tool for all interested in the arts.

Lance Lavine, Professor
College of Architecture and Landscape Architecture
UNIVERSITY OF MINNESOTA

At this point in my artistic journey, I don't spend a lot of time heaping praise on other artists. When I see work I really admire, I usually just find myself quietly thinking, "I wish I'd done that." It's a phrase I often find myself muttering when looking at Doug Lew's watercolor paintings.

My association with Doug started many years ago, when we were both working in the advertising business as art directors doing television storyboards, ads, and billboards. Our art was limited to layouts done with dry markers on tissue for client approval. While visiting a photographer one day to discuss a project, I saw one of Doug's layout sketches. Demonstrated in that simple, humble sketch was more self-confidence, bravura, and talent than I had ever seen in an advertising layout. I immediately knew it was done not just by another art director, but by . . . well, an artist, a *real* artist.

As time went on we continued to work at competing agencies. During this time I tracked Doug's career in advertising and in the fine art watercolors he was doing on the side. I saw his watercolors hanging in galleries and in the homes of mutual friends. Doug's watercolors taught me a crucial lesson: How a painting feels is more important than how it looks. Through the years I also learned something from the man. He is disciplined, demanding, and totally immersed in his work. It always seemed a contradiction to me that someone so disciplined could create art that is so free-flowing and liberated. I have since learned that is what it takes.

Later, when I made the break to pursue painting, I attended one of the local ateliers to brush up on my skills and break the bad habits formed by years of advertising work. This atelier offered the type of academic training so popular in Europe in the eighteenth and nineteenth centuries in which all efforts are focused on the figure. Why? As Doug so eloquently states in his introduction, the figure is the common denominator and universal truth we can all observe and relate to. So it is, with this background, both professional and personal, that I appreciate and admire the beautiful drawings and paintings in this book.

Brian Stewart, Artist and Instructor
Signature member of Plein-Air Painters of America

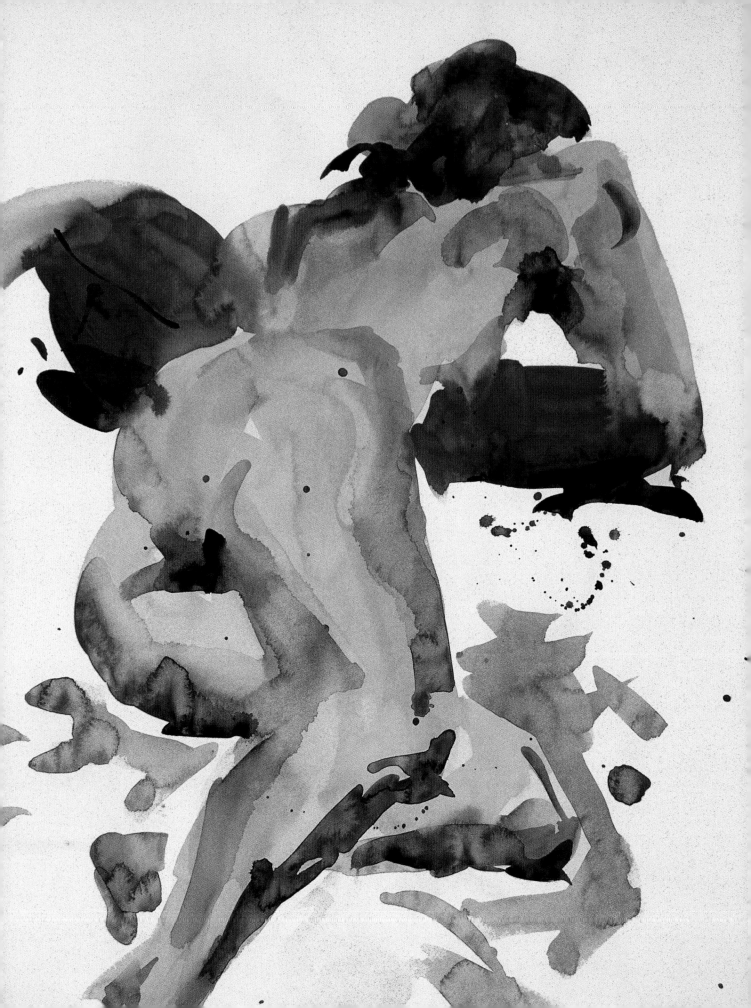

Why do artists draw nude models? This question has been posed to me several times—sometimes in jest, sometimes in earnest. My answer is that there is no better way to develop the skills needed to draw than by working from life with nude models. An artist can afford to be slightly off when rendering other subjects in art, such as landscapes, still lifes, or even architecture; if the human figure is off, it is not only glaring to the artist but discernible to the layperson as well. The human body is probably the most observed object in the world. Every tilt of the head and bend of the torso, every twist of the hip and crook of the knee, every cross and turn of the leg, every curl of the finger—in short, every standing, sitting, squatting, and reclining position of the body presents an infinite variety of views and drawing challenges. The human body offers the challenge and answer to the problems of perspective, foreshortening, proportion, volume, solidity, and accuracy.

About four years ago a friend invited me to attend a life-drawing session at an artist cooperative in a converted warehouse in northeast Minneapolis. I hadn't done life drawing since my college days—some forty years ago!—but I remembered it as being one of the most fruitful and challenging aspects of my art classes. Since college, most of my figure drawings had been done for storyboards for television commercials. When my friend made his suggestion, I readily agreed to go; it would be fun to get back to the basic discipline of art and to associate with other artists!

The Artist Cooperative

Artist cooperatives, or co-ops, exist all over the country in one form or another. Their purpose is to provide models, a place to work, and access to a community of artists. Many are loose gatherings of artists who share the expense for the model and space. Artists pay at the door, and can come and go as they please. Co-ops are usually open to every paying artist. Sometimes sessions are held at the studio of an artist who is willing to share his or her space for free; or they may be held at a community or art center for a reasonable cost. Other co-ops are organized more formally and are member-based, and in some artists may join by invitation only. The group shares expenses through monthly or yearly dues. Some co-ops even share studio space or a gallery in which to exhibit their works and hold receptions.

In addition to saving money by sharing costs, the purpose of a co-op is to give artists the opportunity to improve themselves in all drawing and painting endeavors through continued practice. The co-op gives artists an opportunity to observe how others work, to exchange ideas, and to experiment with different approaches. Each person works at his or her own self-imposed pace and with different levels of determination. I've seen quick and definite improvements in some, and a slow, struggling progress in others; some continue with the same old approach over and over again simply because it is familiar and comfortable. Although at my co-op there is no critique or instruction unless it is requested, some of us do share comments and talk about the difficulties and frustrations of the task.

The disadvantage of a co-op is that the artist cannot dictate either the pose or its length to his or her preference. In some co-ops there may be one long pose for the entire session. Some artists prefer this arrangement to adapting to a variety of short and long poses over a two- or three-hour period. Personally, I prefer the latter since I enjoy the challenge of pacing myself to a given time and exploring mediums best suited to the time constraint of each pose.

My Evolution

Working alongside other artists at the co-op I struck out on my own heightened pace of exploration as I grappled with the ultimate problem: how to draw and paint a nude model accurately and expressively within the time limit of single a pose, even those as short as two, five, or ten minutes. I started by doing single-line drawings, at first with dry mediums such as pencils, charcoal, or Conté crayon, and even my trusty markers from my storyboarding days. After some experimenting I decided that an 18-x-24-inch pad of 80-pound drawing paper usually accommodates what I like to do during the short poses.

For the longer poses—generally from fifteen to forty minutes—I explored wet mediums, starting with watercolor. For the longer poses I used a regular watercolor paper. Since it is heavier—140-pound and 100 percent rag—it can absorb a larger amount of water than regular 80-pound drawing paper, and allow for more subtle and complicated soft edges. The 80-pound paper is better for light washes with a minimum amount of soft edges. I eventually learned that I could use a wet medium for two-minute poses if I restricted myself to doing gesture drawings with a brush, or small black-and-white compositions, such as those on page 24.

At each step in my progress, I set myself new problems and goals. Since my habit is to sketch rapidly, I usually found myself ahead of the given time for a pose, but with figures that were not always accurate in proportion or pleasingly placed on the drawing surface. So I learned to pace myself according to the time allotted, doing simple line drawings for the shorter poses, adding slight shading to the longer ones, and more elaborate modeling with watercolor for the still longer ones. I began to hone in on the accuracy of my lines and the compositional placement of the figure on the paper. Eventually I began to build paintings, sorting out light, shapes, and color as I worked.

How This Book Came to Be

The average number of poses during an afternoon session is around thirteen to fifteen. My practice has been to go over my work the next day and throw away the obviously bad examples and keep the ones I like. The net result is usually about one or two from each session, or sometimes none at all. Yet even at that rate, I have accumulated quite a stack over a four-year period.

One day, as I sifted through the thick pile of drawings and paintings in my studio, I could see the development of an interesting evolution. I realized, as I looked at my work, that I might be able to offer something unusual and worthwhile to both the artist and lay reader: a chronicle of progress in the eternal quest of the figure. Though technique runs as an undercurrent through the evolution, the emphasis of the book is not on how to draw and paint the figure well (there are already many how-to books on the subject of figure drawing and painting). Instead, this book offers artists and lay readers alike a look at the development of the figure in several stages: from a single-line drawing to the gradual modeling of the figure, from a minimal to full use of colors, and from the elements that constitute a painting, including the transformation of the figure from a realistic to an abstract painting. The final chapter is devoted to portraiture—work that is both an offshoot of and parallel to the figural drawings and paintings. Each stage of the development can stand on its own, be examined, enjoyed, and understood. And since every stage is done from life, the resulting work has a sketchiness and looseness from which each artist can develop his or her personal treatment. Most of all, I hope that my experience helps to enlighten and encourage the reader about this most challenging of all artistic subjects.

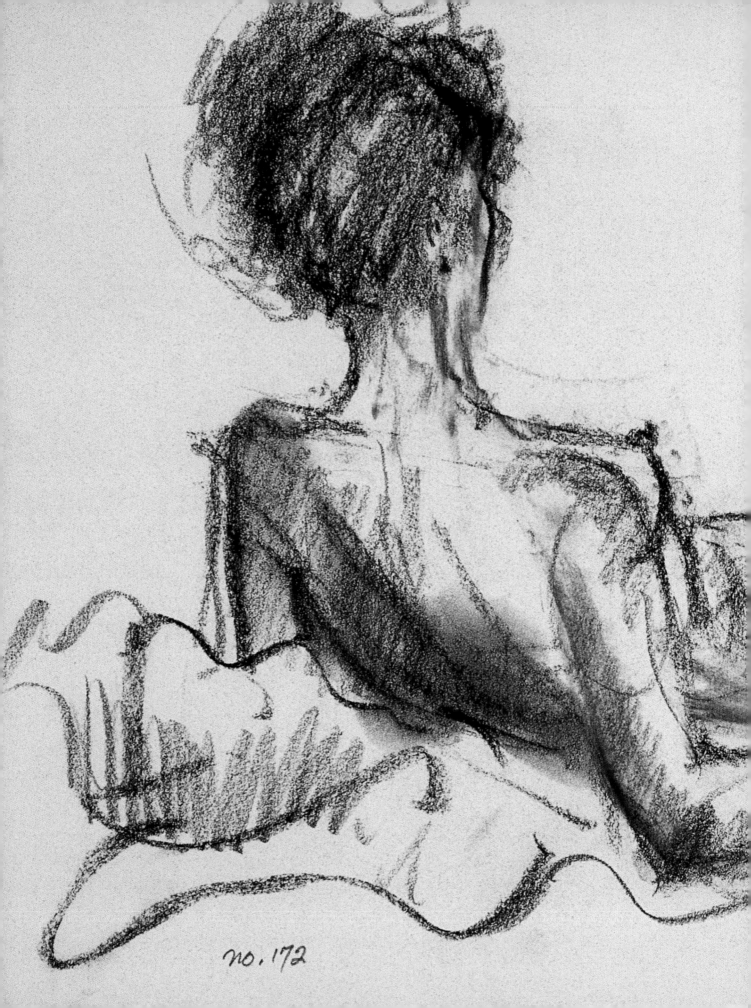

no. 172

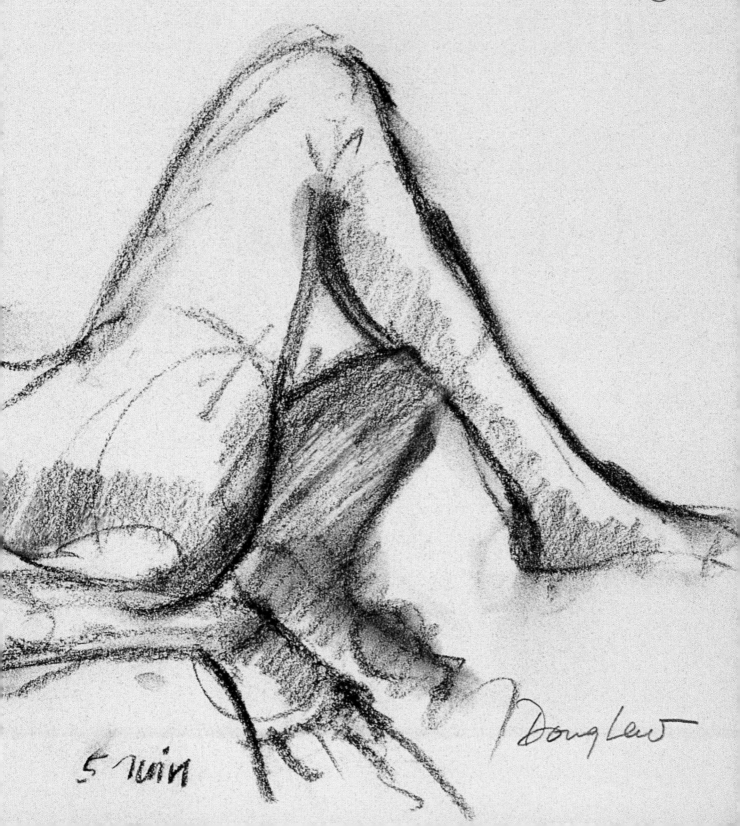

5 min

The Virtue of a Single Line

A pose of only two minutes requires a great mastery of eye-and-hand coordination to depict the figure accurately. I found that the single line is best suited for short poses—you either get it or you don't. The depiction of the figure with a single line seems simple enough to do, and when it is done right, it carries a simplicity and purity of expression that's a true delight. Yet, because of its purity and simplicity, it also can be the most difficult: The bareness of a single line exposes itself completely to the slightest error, and you can't use layers of line or modeling to help compensate for inaccuracy. To be sure, there are many single-line drawings that disregard accuracy and exaggerate or distort for the sake of a particular expression or purpose. The drawings of Henri Matisse (1869–1954), Pablo Picasso (1881–1973), Auguste Rodin (1840–1917), and others come to mind. My evolution, however, began with the goal of accuracy.

There are numerous methods to draw using the single line. Some of us try for a continuous line without lifting the tool off the paper; however, this requires a decisiveness that can be achieved only with a lot of practice. Other artists begin by overlapping lines. I do this myself sometimes, but I try not to hide behind tentative chicken scratches that betray either a timidity to commit or a lack of observation. Over time, I learned that commitment and observation are the ultimate skills I needed to do a good line drawing. I would rather toss a bad sketch, start afresh, and save the time for shading than struggle to improve upon a tentative start.

It's interesting to see the variety of approaches during an artist's initial phase at the cooperative. Some artists use newspaper sheets of enormous size and wide charcoal sticks, smudging with their fingers and covering themselves all over with black charcoal dust. Some use sharp, pointed, color pencils on a tiny pad doing ever-smaller figures. Some stylize the figure, and others try moving around the model; but all are intent on what they are doing.

Different Mediums

In the first year at the co-op I did mostly drawings; I wanted to reacquaint myself with different mediums—charcoal, soft pencils, Conté crayons, pen and ink, felt-tips, and even markers. All of them could be used for short poses or much longer ones for greater degrees of finish. I find charcoal to be most sensitive and expressive in depicting volume and punch but also the messiest to spray fix and keep clean. Conté crayons are similar to charcoal, though less flaky, a kind of a cross between charcoal and lead pencils. I like the versatility of 6B-pencils or lead sticks; they glide easily across the paper and allow modeling to be controlled by touch. Pen and ink or felt-tip pens are better for small-scale drawings—12-x-9-inch or smaller. Markers aren't permanent but are good for small renditions and for quick studies, but gradations are difficult to accomplish without changing sticks. Some interesting effects can be achieved using half-dried markers for the middle tones.

As time went on I found myself using the short poses of two to five minutes as exercises just to loosen up—much as a gymnast warms up for an athletic event—concentrating only on gestures and single-line drawings. For the slightly longer poses—five minutes or more—there is time to do more shading and modeling, and to build more volume. When longer poses are struck, I'm eager to tackle those with watercolor. I found that my washes are faster and more fluid if the drawings underneath are accurate. On occasion I have tried two-minute poses with washes right from the start without pencil guidelines, which require an even greater degree of observation and eye-to-hand coordination. These can be scary, but well worth trying, because one has to achieve both light and dark shading and accuracy at the same time.

The Search for Volume

Drawing is the foundation of any realistic endeavor. It carries the responsibility of accuracy of line, proportion, perspective, and volume—none easily achieved, but all possible, given enough time and effort. The first three—line, proportion, and perspective—can be accomplished with an exactness of line, but only volume gives a subject its three-dimensional quality that makes it jump off a piece of paper. All mediums can achieve volume with light and shadow modeling; even pencil—with enormous amounts of modeling and time—can accomplish a lifelike realism. However, since at the co-op I had only forty minutes at most to draw or paint a model, and sometimes five to ten minutes or less, my challenge was to get the most volume in the shortest time with the most suitable medium. And wash, for me, stood the test.

The Speed of Wash

My introduction to the brush came early in life. I grew up in Shanghai, China, during World War II. At this time all schoolchildren, from age six on, were required to practice calligraphy for about an hour a day, and by age twelve all were proficient. Using ink and brush, calligraphy is also closely associated with Chinese painting; its behavior is also somewhat akin to watercolor. Since watercolor had been my preferred medium even before attending the co-op, it was natural for me to think about using it when drawing got tiresome. My familiarity with a brush is such that I could, with a properly charged one, accomplish the same degree of volume and gradation with one stroke that I could with twenty or even thirty strokes of a pencil. For me the speed of wash is the best match for the time allowed. Lately, because of demand, the co-op occasionally has a forty-minute pose; yet even that span of time is too short to bring off a finished work. For the forty-minute poses I sometimes use a heavier-weight watercolor paper, which offers a better absorption of wet-into-wet treatment and a smoother intermingling of colors. The brush's versatility served as a bridge between the drawings I did in the early days at the co-op and the paintings I undertook later.

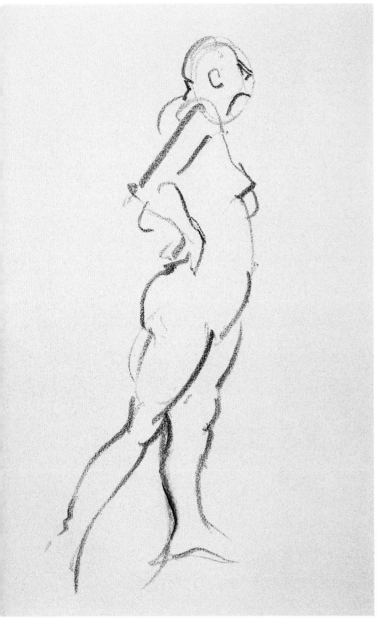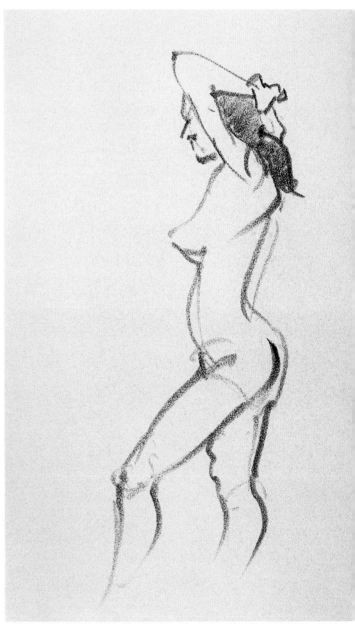

These four single-line drawings were done during two-minute poses. During this early stage at the co-op I focused on indicating an outline of the figure. Sometimes I started out by first drawing a very faint circle to establish the size of the head, which allowed me to draw the rest of the figure in proportion to it (see the far left drawing). Other times I started at the shoulder, or at a raised arm, and worked downward.

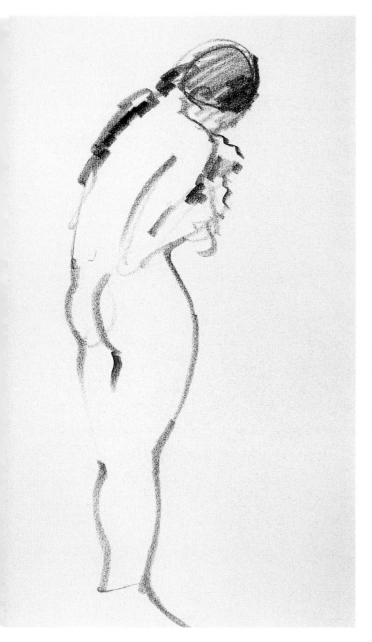

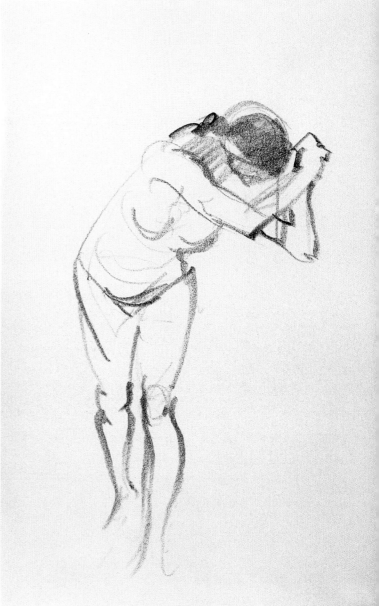

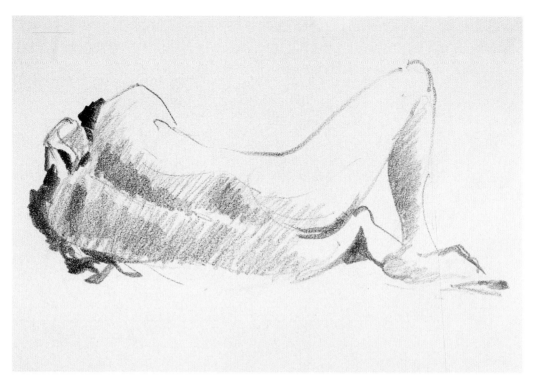

During these two-minute poses I found I had enough time to add a minimum of shadow to modulate the form.

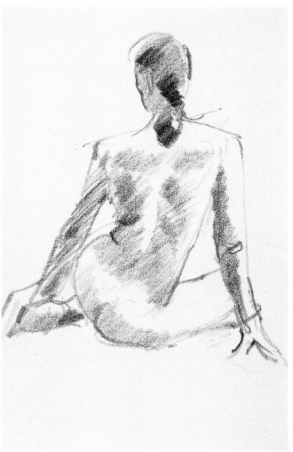

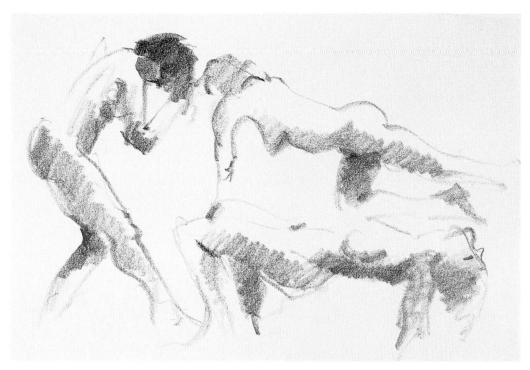

Sometimes I would group several figures on one sheet of paper just to see how well they fit together.

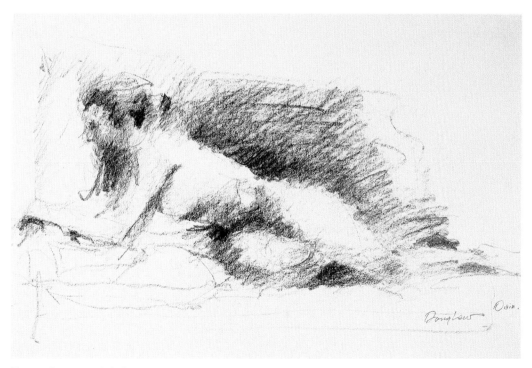

To vary the approach, I dispensed with outline and used just shading to define the figure. I highly recommend this exercise as it forces one to concentrate on the correct distribution of value and, at the same time, pay attention to a correct drawing of the body. I used a 4B-pencil on this one but I could have used Contè, charcoal, or pen and ink as well.

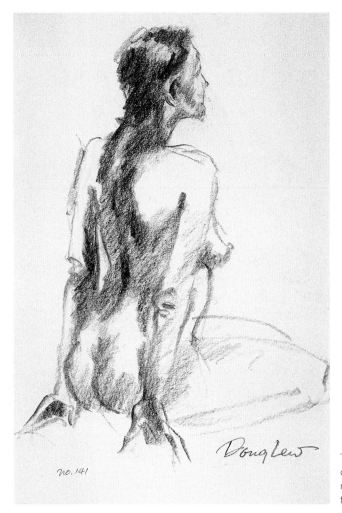

no. 141

These five-minute poses, including the one opposite, gave me more time for modeling. The forms were beginning to fill out, but just barely.

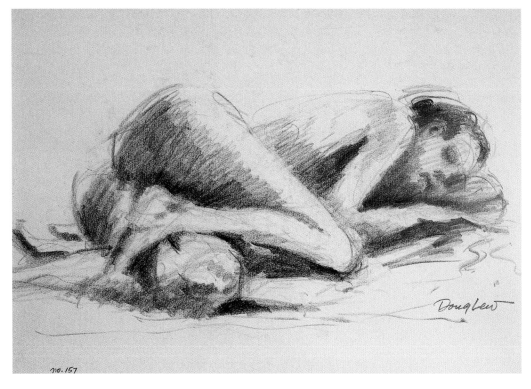

no. 157

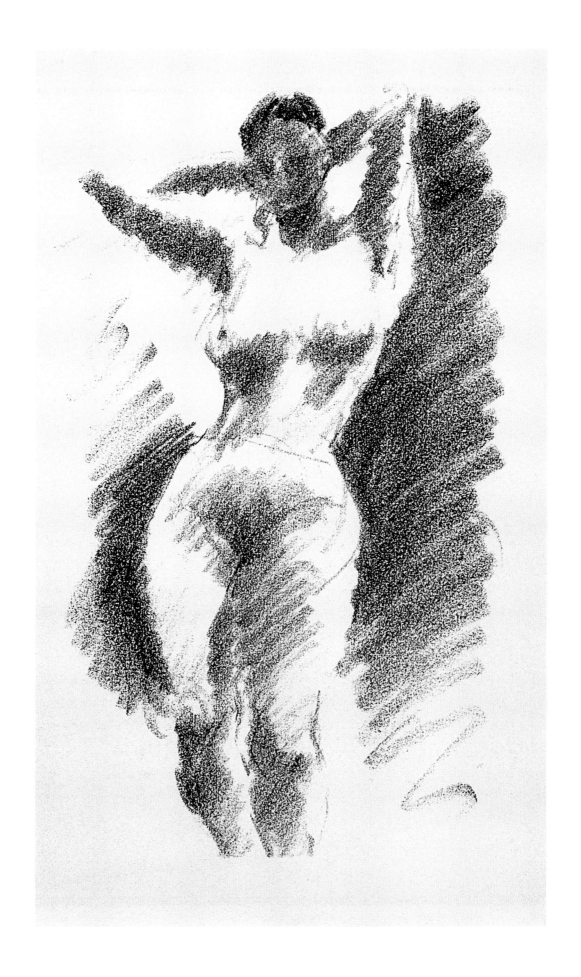

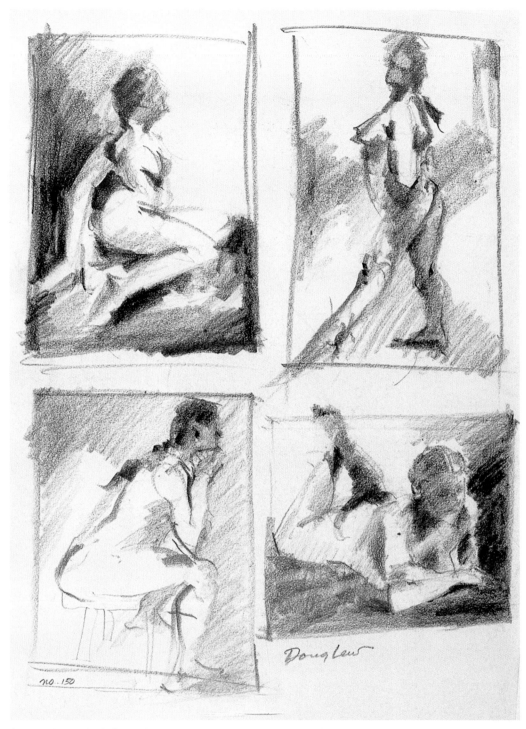

As an early exercise in figure placement, I drew squares on my sheet of paper. Since this exercise was done on a small scale, I found it easier to judge whether I'd placed the figure well. The slight shading I added around the body was the beginning of my compositional considerations.

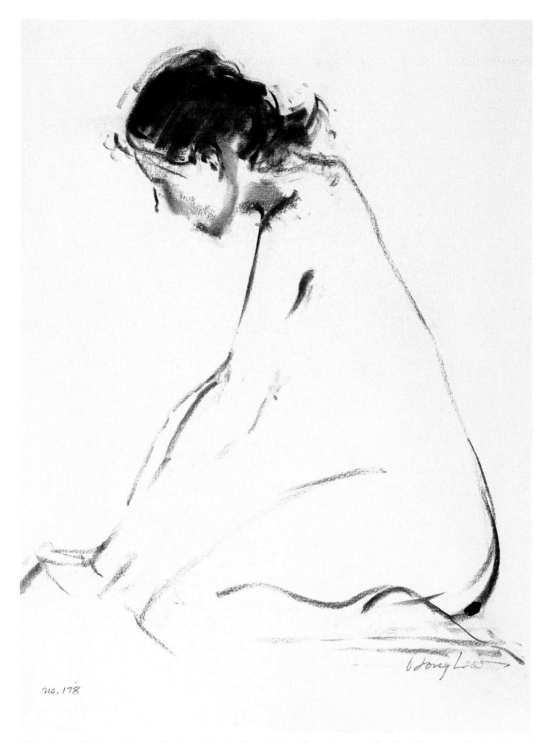

no. 178

Using charcoal, I placed the head where I thought it would best fit on the page. Then I quickly massed in the hair and lightly shaded the cheek, chin, and neck with my finger. By then I had realized that a five-minute pose would not allow me to do the same with the rest of the body, so I chose simply to outline the body with just a few lines to define the bend of the knees and hands. It worked out well, partly by accident and partly by design.

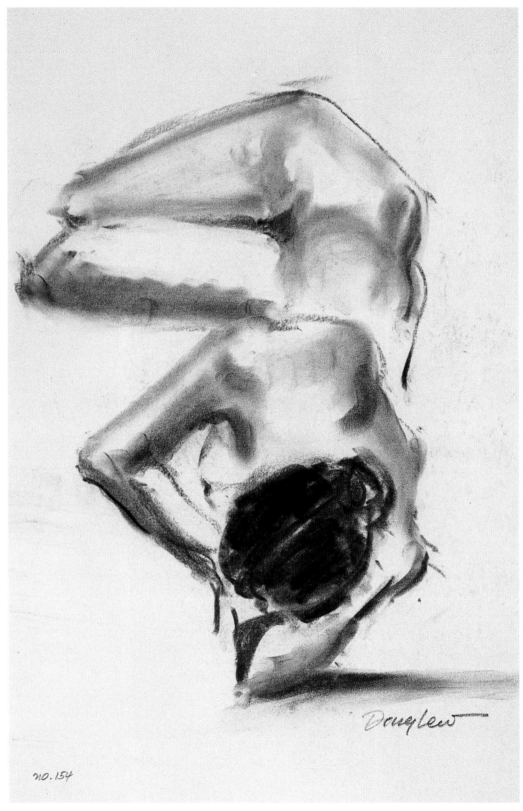

no. 154

This drawing and the one opposite were done with medium-weight charcoal sticks and with finger rubbings to modulate light and shadow. It's fun to see the form emerging, but I recommend not overdoing the rubbing; it can camouflage the solidity of the drawing and hide the strength of the lines.

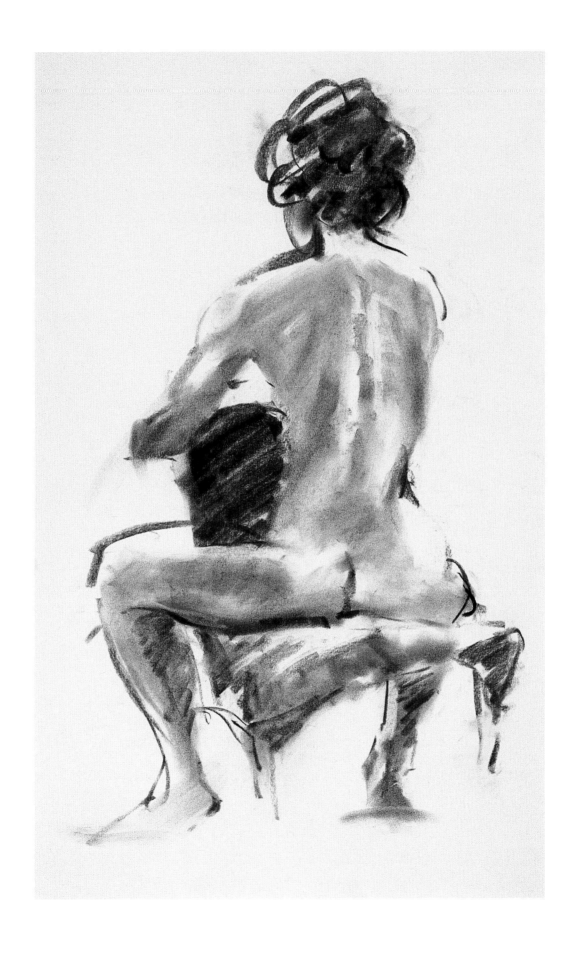

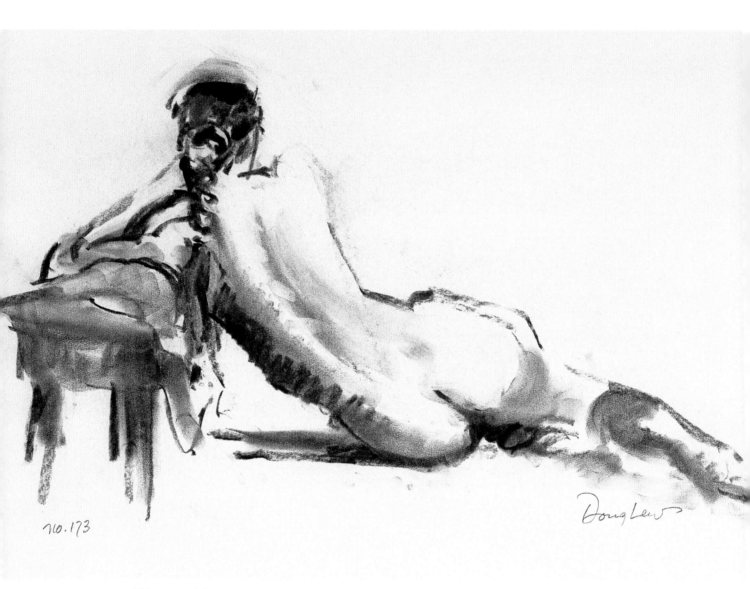

no.173

This pose and the one opposite were longer, about twenty minutes each. This drawing was done using lines and rubbings, the one opposite with lines only. The time allowed me to carry the drawings to a greater degree of finish. I preferred the one using lines only. Using lines only to suggest modulation is more difficult, but it reveals the solidity of the drawing. Rubbing is an easier way out but also, in a way, a cheat.

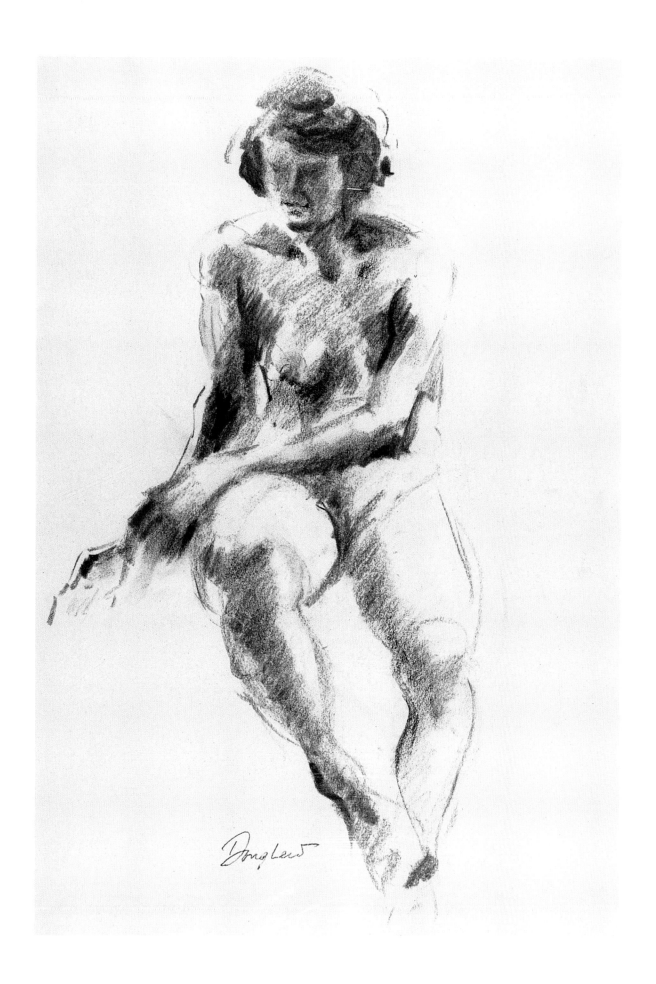

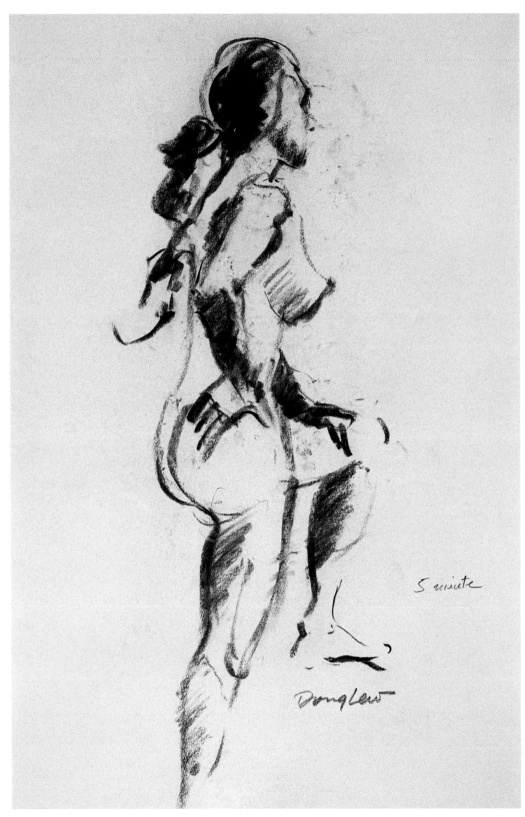

5 minute

DongLew

At the co-op many artists use heavy finger rubbings to suggest modulation. While charcoal rubbings suggest three-dimensionality, they are ultimately void of strong drawing. That is why for this drawing, and the one opposite, I deliberately avoided rubbing with the charcoal and used the charcoal stick only in the shadow areas with minimum modeling. The strength of this approach lies not just in getting the gesture right but with slightly exaggerating the pose. A common failure of drawing I see at the co-op is stiff figures with only minimal curves and twists. To give a gesture a sense of lifelike vitality, the trick is to slightly exaggerate it.

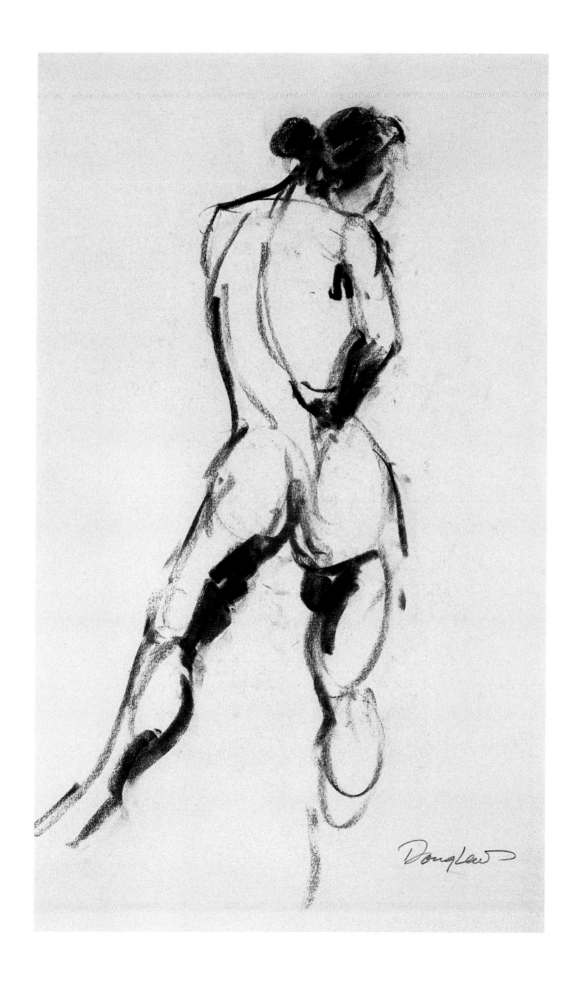

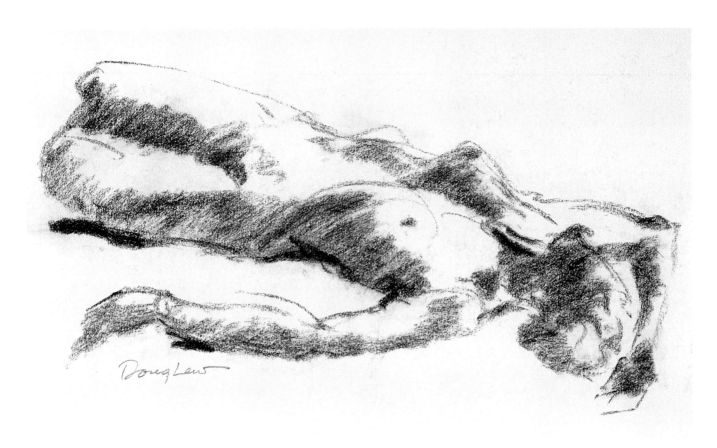

These drawings and the three opposite were done with a brown Conté crayon, a medium much preferred by the French. Personally, I found it not as facile. I had to use more energy for the rubbings, and I still had to use a fixative to keep them from smudging.

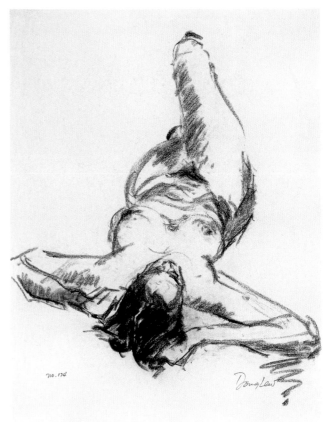

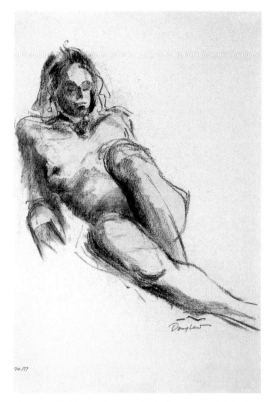

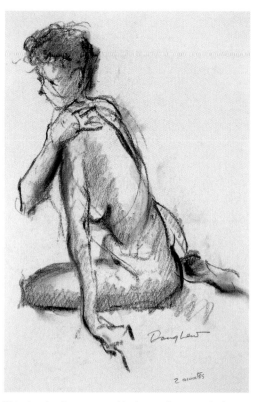

I later used this drawing as a basis for a more finished watercolor.

This drawing became a guide for an abstract painting.

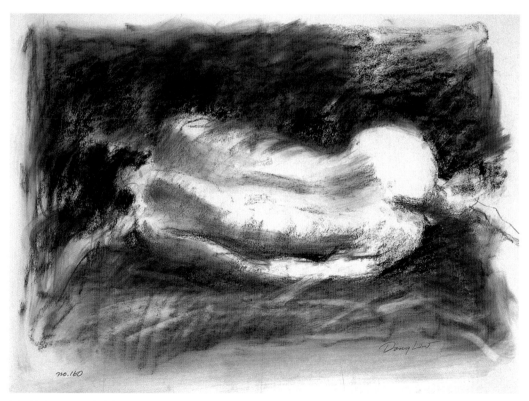

I decided to use a dark background to outline the pose. The strokes and rubbings were so laborious that I remember deciding then and there to try wash.

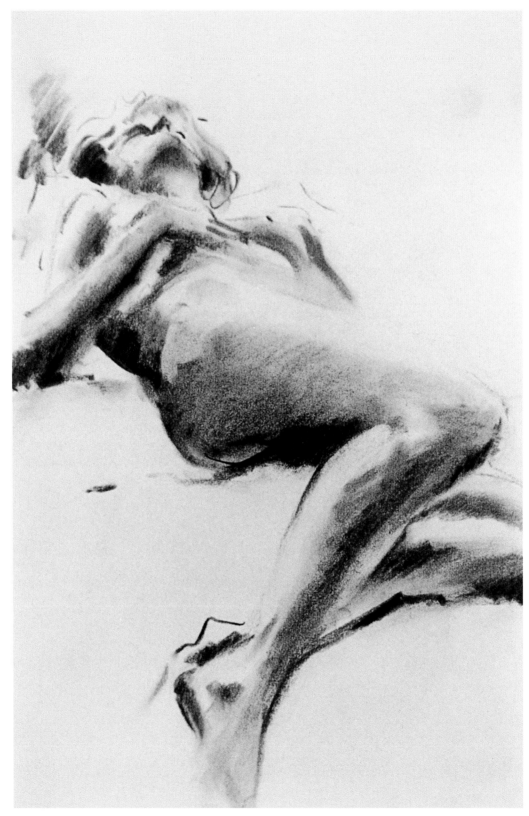

This drawing is probably the most finished one I did during a twenty-minute pose. I was sitting about five feet away from the model. The foreshortening was such that the legs loomed very large. The tilt of the head offered an unusual angle. There wasn't enough time to indicate the fingers and toes but, as a whole, I thought the drawing held together rather well.

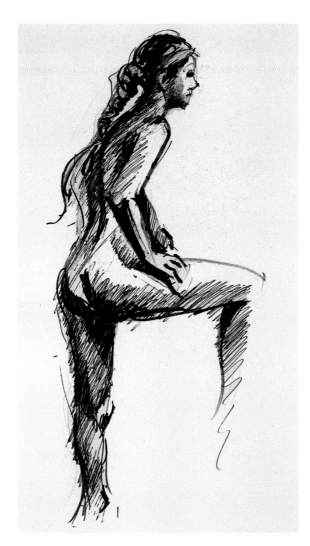

These drawings were done with a large, pointed felt-tip. A worn, half-dried felt-tip was used for guidelines. Felt-tips can also be used quite effectively for halftone modulation. They can accomplish the same thing as the old masters' pen and ink, but with more efficiency since they have relatively supple tips. Just make sure the ink of the pen is permanent or it will fade.

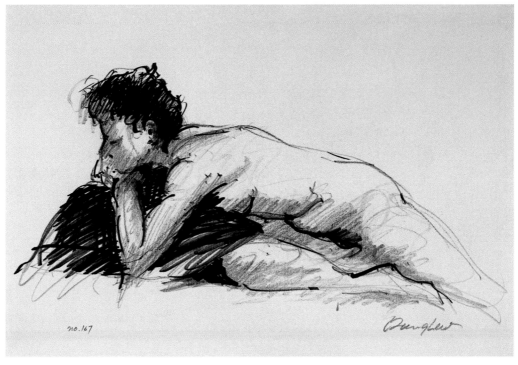

no. 167

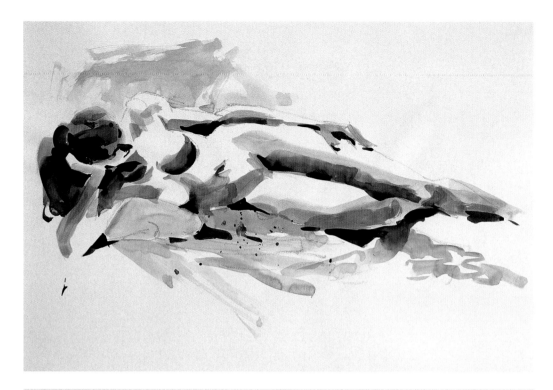

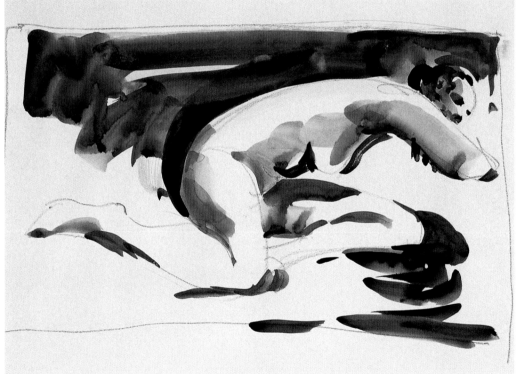

As you can see, with a fully charged brush I could fill the upper part of the background using fewer strokes—four or five—than I could with the previous one, and more simply and with more dash. The modulation of the figure is done with simple brushstrokes—a faster and more spontaneous effect.

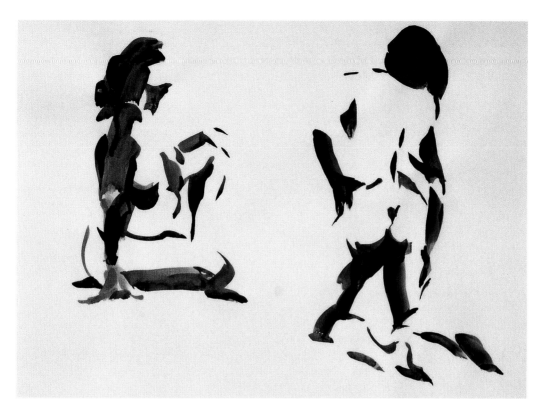

Having felt the release and exhilaration of the wash, I next decided to experiment with abandoning pencil guidelines. This time I plunged right in with wash just to see how accurately I could nail down the drawing. I squinted my eyes to locate the main shadows and placed the shadow wash where I saw them, almost without any gradation.

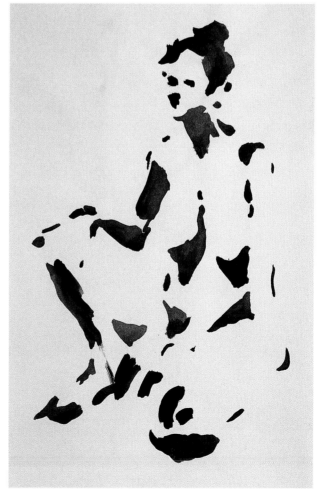

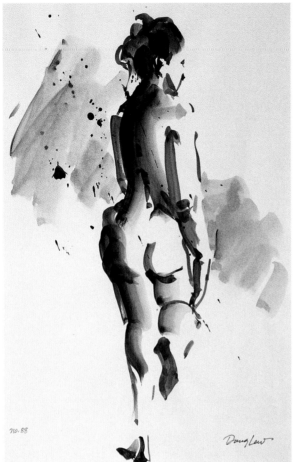

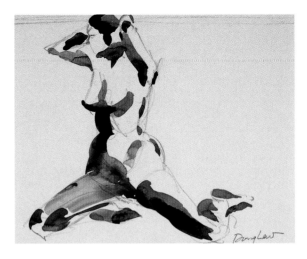

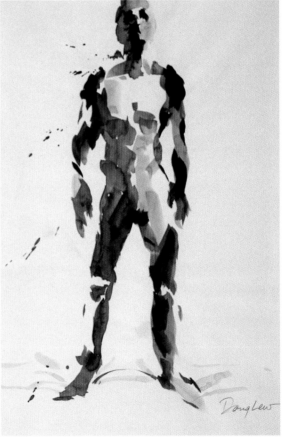

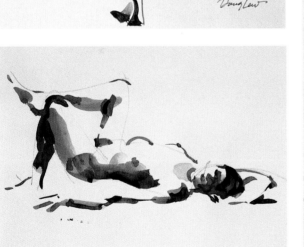

When I used charcoal, pencil, or Conté crayon for large, dark areas, I found it labor intensive or, rather, stroke intensive. I could cover the same areas faster with wash. For a five-minute pose, the secret of using wash is to do the pencil drawing first quickly in light outlines. You should spend no more than two minutes at this, since you want as much time as you can get for the application of wash. I learned that wash corrects and covers an inaccurate drawing at the same time. For modeling gradation, I applied the darks first and softened the edges of the drawing with a clean, moist brush, not a dripping-wet one. The ordinary drawing paper I used was less absorbent, so a deep, wet wash would be difficult to control. I used a large oval brush with a pointed tip—also called "cat's tongue" (see page 42)— that could hold a hefty charge. Using a cat's tongue brush I can press down and create with one stroke a dark-to-light gradation. I used the tip of the brush to indicate a dark, sharp edge and the end part of the brush, slightly lifted, to indicate the transition to light areas. I used the same brush for the two male poses (see the lower right wash on this page and the upper left wash on the opposite page), but decided to do the value gradations in hard edges only. The gradations are accomplished in separate sequences of passage—from light to dark. Each sequence is, more or less, almost dry, offering a different effect. Such is the versatility of the single brush.

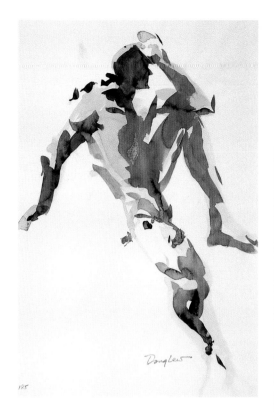

185

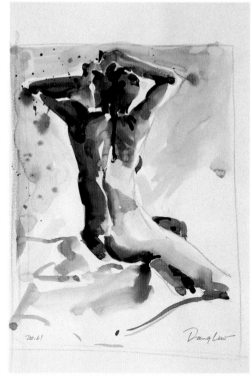

no.61

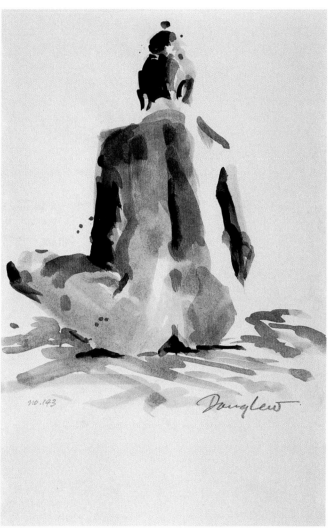

no.143

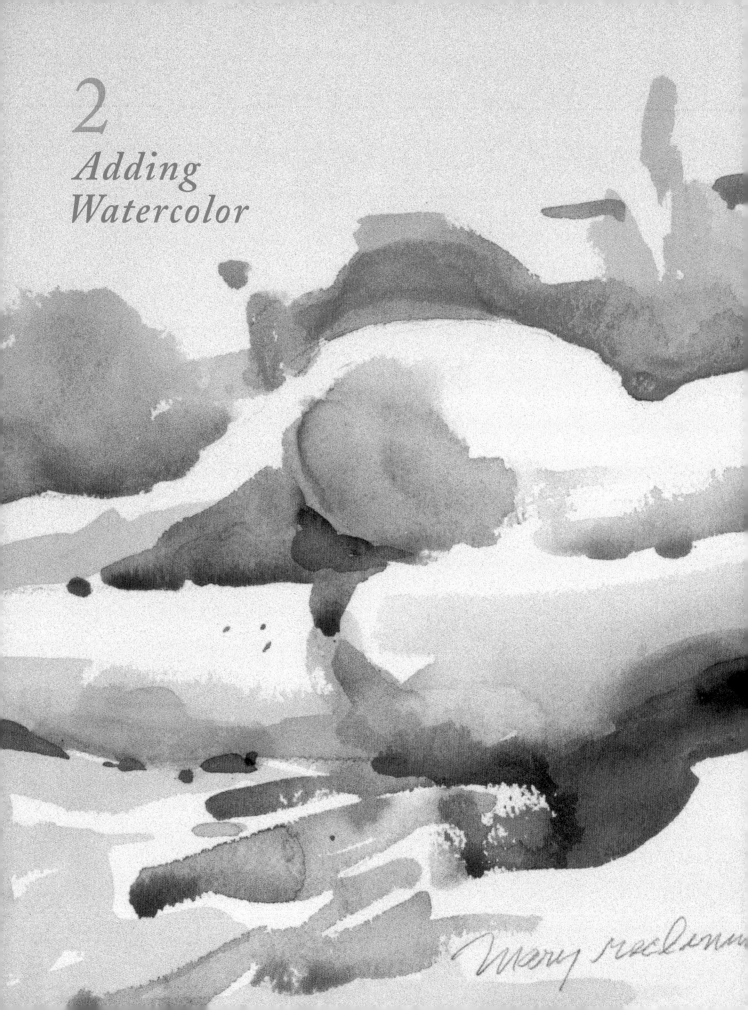

2
Adding
Watercolor

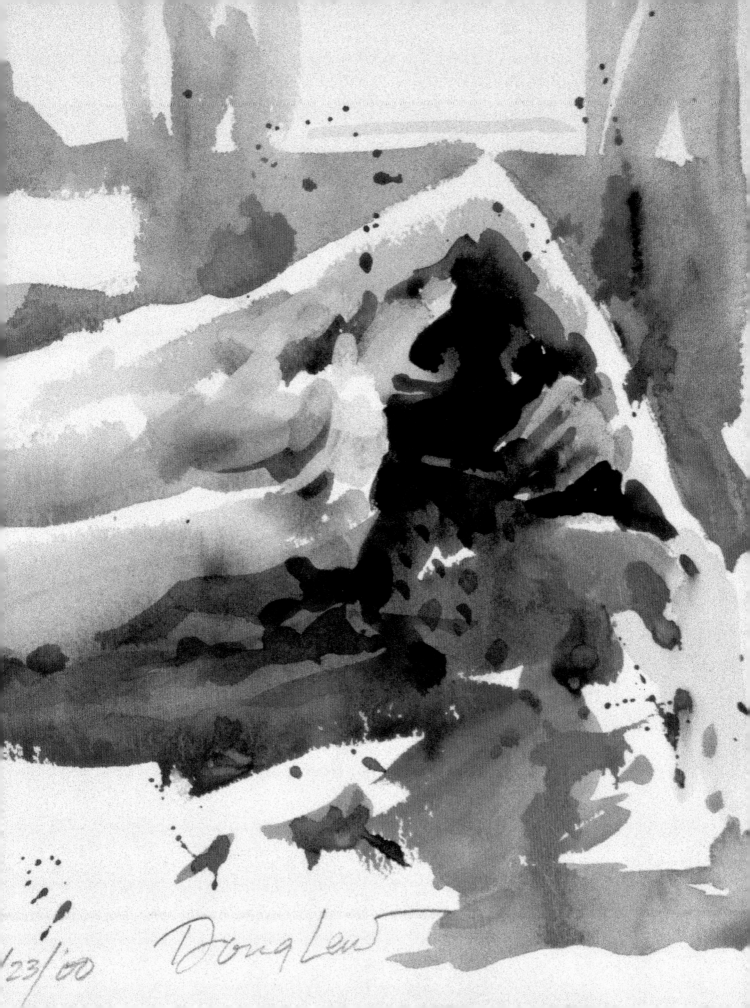

123/00 Doug Lew

The Value of Time Constraints

Short poses can be frustrating, and especially when one is confronted with an unusual angle. There is never enough time with any medium to bring off a finished work, but short poses offer enormous benefits if one confines the given time only to outline drawings or gestural painting. Doing so sharpens one's power of observation and jump-starts hand-and-eye coordination, the practice of letting the hand follow the eye.

The big question is, "How do I get the maximum effect in a short time?" For me the answer lies in watercolor, a medium I've been using for years. It proved to be the best way to add volume quickly. It also allowed me to move beyond the monochrome wash and to begin to introduce and experiment with a full range of color.

The demands of the short pose remind me of a particular style of Chinese painting that uses a minimum of strokes to render form. The artist is asked to look intensely at an object, perhaps a bird. As he observes the bird he is also trying to figure out in his mind how to paint it with a minimal number of strokes, in what manner, and in what sequence. In proportion to the painting process, the observation may be long. The artist's visual analysis is so concentrated that he is able to walk away from the bird and later paint it from his mind's eye with only the briefest of strokes. I've always marveled at these paintings, and perhaps that is the reason why I am drawn to watercolor in my own work as a logical solution to the time constraints of the short pose.

The Right Tools for the Job

The average number of poses in three hours is about twelve to fourteen. I decided, after some experiments, to use a good 70- or 80-pound drawing paper that allows a light wash for the shorter poses. Since watercolor paper is heavier it requires more time to take proper advantage of the paper. It's also more expensive, so it would have been a waste to use it for the shorter poses. The lighter-weight paper was sufficient for the task, and considering the amount of paper I go through in a typical afternoon, much less expensive.

To achieve the effect of light and shadow I used a large, oval, squirrel-hair brush that is commonly called an "oval wash with a tip" or a "cat's tongue" since it comes to a point at the tip like a cat's tongue. It allows me to perform a wide range of functions—from a broad sweeping wash to a fine line to spattering—without changing brushes. It also enables me to indicate value changes from hard to soft edges with one heavy pressed-down stroke, another time saver.

Which Colors and Where to Put Them

In short poses, getting to the essentials as quickly as possible is crucial. So, like many artists, I squint to eliminate details. I concentrate on the shadow areas, putting down only those with

fairly pure colors. I leave blank the areas that are struck by light. It's amazing how quickly a mere hint of shadow areas will suggest the effect of three dimensions. I take special care to make sure that these dark areas are not dotted all over the body. This can look very spotty and busy, so I use very limited halftones as a means of connecting dark spots and giving a work an interlocking effect that's pleasing to look at. At other times, I carefully put some wash outside the body to help define the body shape and some strokes of uneven value for cast shadows wherever they may appear.

Warm, Cool, Complementary, and Why

Of course working with watercolor allowed me not only to quickly describe volume, but also to add the element of color. Generally speaking, a large amount of warm peach with a light touch of a cool color (cerulean or manganese blue, for example) fused on the edges gives a glorious skin tone. However, repeated use of the same mixture gets monotonous. In the beginning, I tried to match the color of the skin tone as I saw it on each particular day (light can vary according to the season; summer light can be different from the short days of winter when, by necessity, artificial light takes over in the studio).

Gradually I found that it was best to concentrate on where the light was hitting the body and to leave those areas white. This method gives the greatest punch. Color in the shadow area is arbitrary: It can be cool or warm depending on the quality of the light that's falling on the body. If a cool light is falling on the body, one usually uses a warm shadow color; if a warm light is falling on the body, one usually uses a cool color. If the light is neutral the shadow area can take either a cool or a warm color, or a combination of both. It's fun to experiment, mixing warm with cool together in a continuous flow, and it is more exciting for the viewer. If you stare at the body long enough, you begin to see all sorts of colors, particularly at the edges where shadows begin to darken. A touch of complementary here and there gives great visual stimulus when matched against a dominant color.

Over the years I discovered a few interesting things about color. I learned that cool colors don't always recede and warm colors don't always come forward. For instance, cobalt blue is so intense that it jumps out when it's placed next to other blues or when it is used with some neutrals. Alizarin crimson gives the deepest and richest dark shadows, receding even more than indigo. Purple is versatile. Riding on the edge of warm and cool, it can easily fall over into the warm tones when mixed with more permanent rose, and it can fall over to the cool side when mixed with any of the blues. Sap green for the shadows of the body can give a real jolt, especially when the darkest area is mixed with turquoise or viridian.

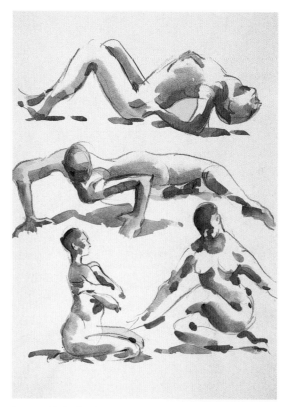

Shana is stocky, well-built, and very athletic. She loves dynamic poses and relishes in twisted and contorted positions that are a real delight to draw. I wanted to make sure I captured her poses in strong and definite outlines before I put in the colors. When I started using one-color washes it was an exhilarating change, in speed as well as in the fluidity of the look. The thought of using watercolor came almost immediately. These two-minute poses are just long enough for a sparing use of color in the shadow areas. I managed to fit four poses on the same page by keeping the figures small, fitting them in quite by accident.

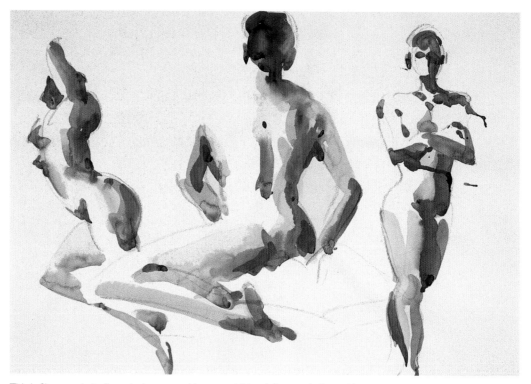

This is Shana again in five-minute poses, giving me additional time to do just a bit more modeling and color variation.

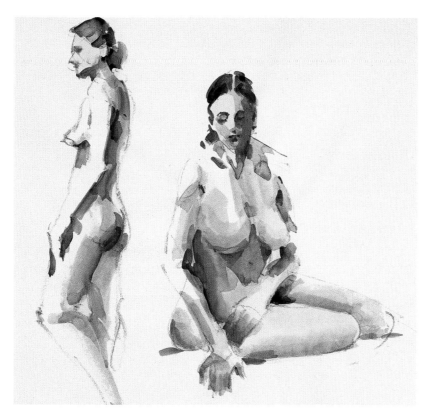

Kathy is a great model, experienced and confident. Her poses are always natural and her body lines speak volumes about her femininity. I started with one color—a light mix of permanent rose and cadmium yellow—and quickly began to add more colors as the poses became longer. I wanted to alternate the colors between warm and cool to lend excitement. In these poses I discovered that some blues, such as cobalt or manganese, did not always recede and that alizarin crimson gave the deepest and richest recession.

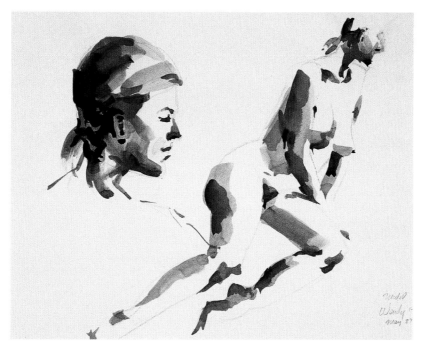

The models tell the artists how long a pose will be so that we can pace ourselves accordingly. Since this was a short pose I didn't try to paint it with soft edges, which would have taken more time. I also did it small, placing the full body on one side of a horizontal page. I was finished ahead of time so I painted the head next to it, also using only flat tones.

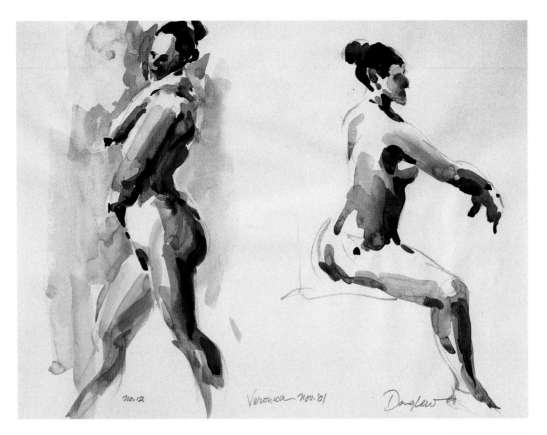

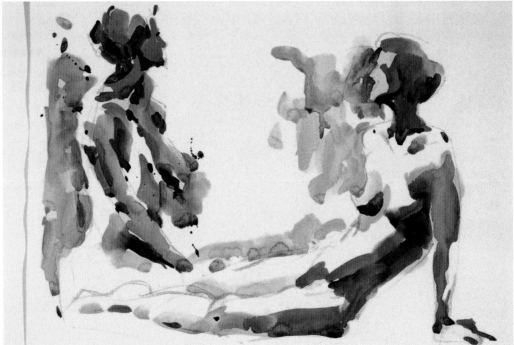

I continued alternating the colors between warm and cool and leaving the light-struck area white. I also began using just a light wash outside the body to delineate its shape.

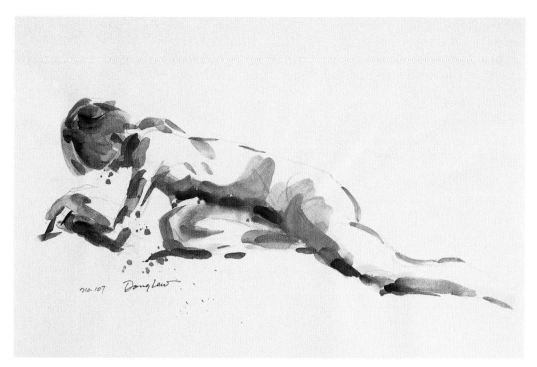

Mary was holding onto a pillow for this pose, though I didn't have time to indicate it. I like the way the drawing looks as it is. I started with light blue, thinking at first I would paint the whole thing in blue tones, but I changed my mind as I was finishing her head. The two colors—a cool blue and a warm flesh tone—looked too starkly different and too evenly distributed so I turned it more to the warm side by adding some additional reddish brown under her body here and there to give it some linkage. Now it looked different rather than odd.

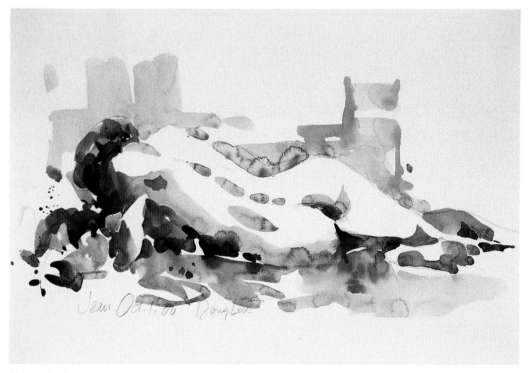

This model, Jean, is a runner and an artist. She has tremendously muscular legs and a rather thin upper body, which gives a real insight of the skeletal structure of the upper body. Although the pose was twenty minutes I attacked it as though it was a shorter one, using as little line as possible. Having finished ahead of time allowed for the pose, I looked at it critically and thought the whole rendering was a bit pale, with the hair being the only dark spot. I decided to add some more dark colors below the hair and under the armpit to give the piece a focal point and more punch.

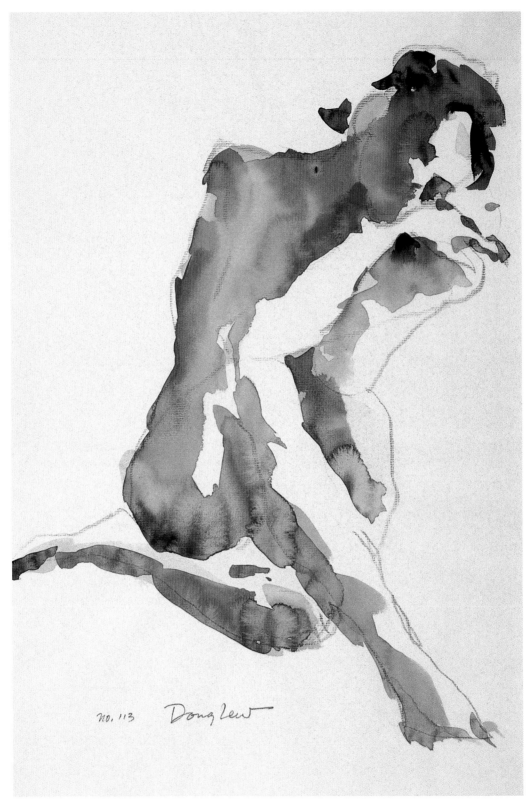

no. 113 Doug Lew

This is a good example of lost edges. I lost them intentionally for two reasons: to eliminate line separations and to connect shapes, such as the model's elbow and her knee. I wanted to find out if the gesture of the pose as a whole would still survive the obfuscation. The drawing had an abstract quality that I liked, and hinted at developments to come.

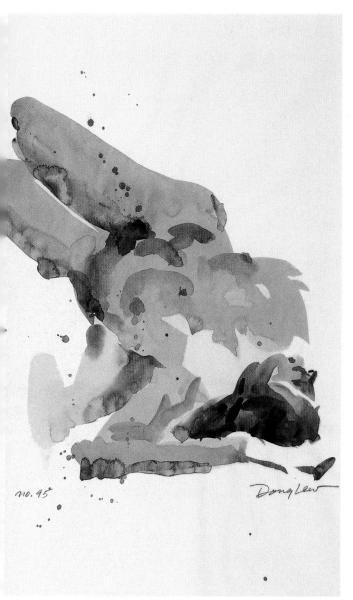

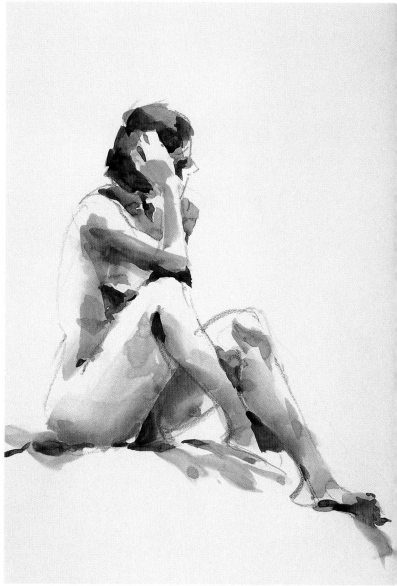

The painting to the left was done without any pencil guidelines; it was more free but had a few misses. The painting to the right was done with pencil guidelines and was more accurate. Since I finished it ahead of the time allowed I was tempted to develop it further by filling in a background. But the clarity of the pose was good and the shadows well placed, so I left it alone.

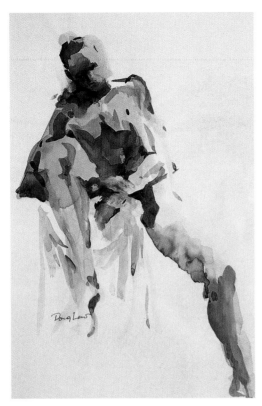

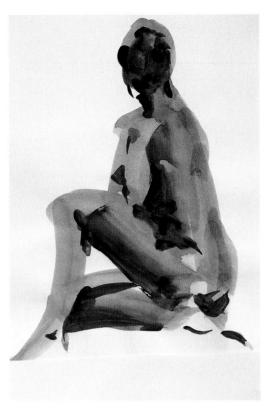

Chad is a great male model, long limbed and muscular. It's good to paint some blocky forms for a change.

When no pencil, or very little, is used it's best to concentrate on gestures and use only a second darker pass for the shadow area to convey form. These are great exercises; I kept many of them in different colors and threw away many misses. I'm a great advocate of this approach for artists of all levels. When you hit a good one the reward more than compensates for ten misses.

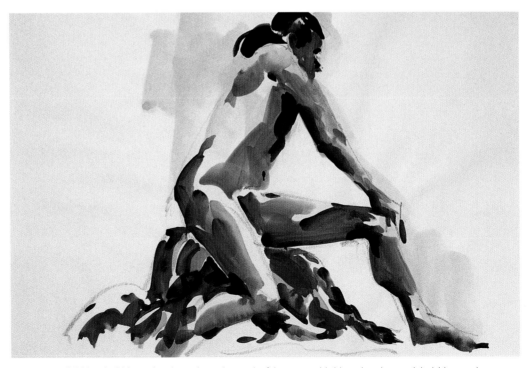

Octavio is a full-blooded Mayan; he always brought a colorful serape with him when he modeled. I love colors, so I always tried to include his serape if I had time.

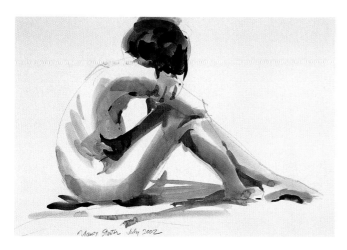

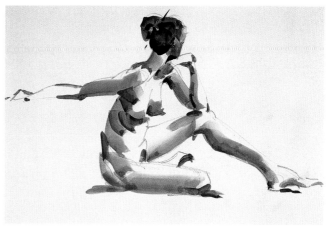

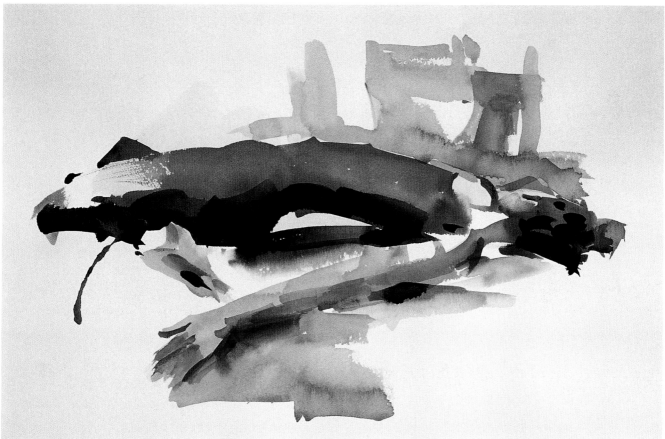

The constraint of time forced me to do some useful things: to accurately nail down the drawing as fast as I could with as few lines as necessary and to start the painting with as broad a stroke as I could to cover as much area as possible. Generally speaking, my practice is to work from light to dark, putting down the first, second, third, and fourth passages in increasingly darker values as accurately as I can. This practice requires a quick analysis of the figure to discern where the lightest and darkest areas are. The subtleties of the mid-tones are hard to pin down as they often contain different colors of the same value. This analysis can be learned only through a lot of practice and rigorous observation. The bottom pose is a good example of nailing down the values accurately and decisively.

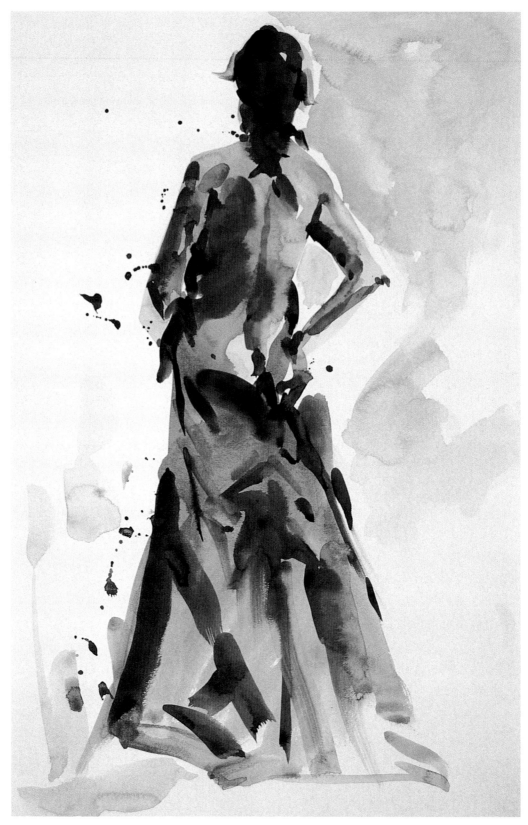

I penciled the figure and the wrap, and with just a few lines indicated where the big folds were in the cloth. I began with a light skin tone, applied a darker one with minimal blending, and followed that with the darkest tone, almost without blending. I did the model's hair next with just two colors—burnt sienna and burnt umber—letting the two blend quickly. For the wrap I mixed a green to match the true color of the wrap; then, with a clean wet brush, I diluted the green to cover the entire wrap. I added darker green for some blending, and finally the darkest green was put in without blending. The spattering added a spontaneous look in keeping with the sketchiness of the drawing.

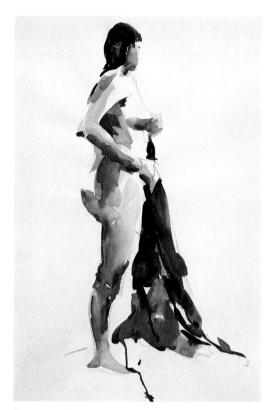

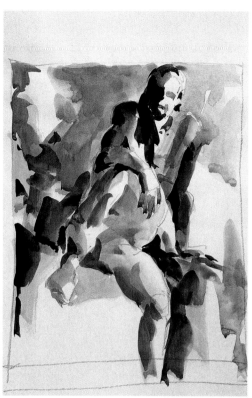

Once in a while I would start to apply a neutral color and, in the middle of it, change my mind. Usually I made the change because the color looked so dead and bland. In the pose on the right, I quickly added a touch of grayish blue, instantly giving a richness to its neutral treatment. In the pose on the left I changed the color of the model's wrap from green to burnt sienna, causing the neutral color of her body to take on a warm and quiet resonance.

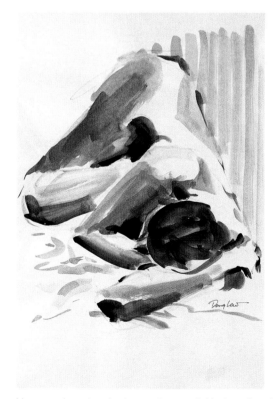

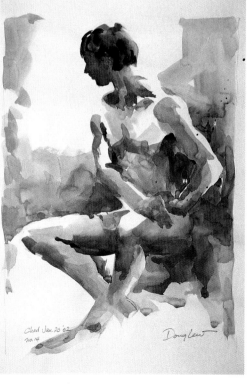

I began to introduce backgrounds around this time, though my treatment of them was always sporadic. (Even to this day I sometimes neglect the background if I'm diverted by the figure, or even just the model's face.)

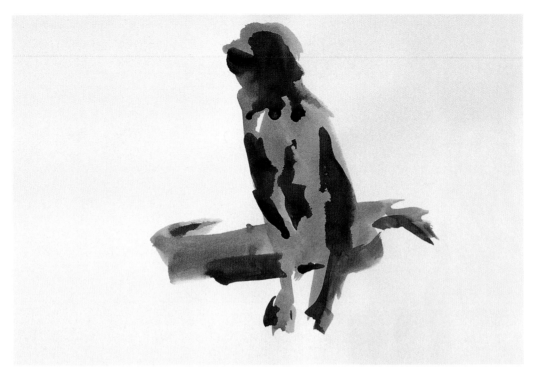

For this pose I used very little pencil, or none at all, and focused on getting the model's gesture down as quickly as I could.

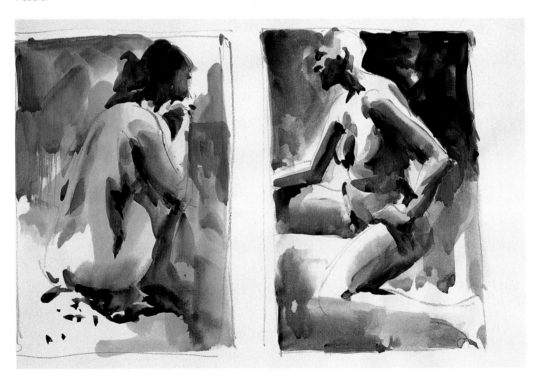

Micole, the model, had long arms and legs, tattoos on her body, and a shaved head. Both of these poses looked odd in sketch form. I was able to add some hair to the left drawing. The one on the right looked like a man with breasts. There was nothing I could do since I had already outlined the model's head with a dark background. In both sketches, the edges of her legs were lost deliberately to improve the compositions. To extend and complete the leg in the left drawing I would have had to move her to the left for better balance; losing the leg was a better option. In the drawing on the right, I could have darkened the area in the lower left to create a clearer outline of the model's left leg. However, this would have been a bad compositional choice since I would then have had a too-equal balance with the dark shape at the upper-right portion of the drawing. So given the circumstances, I thought it was better to leave her legs undefined.

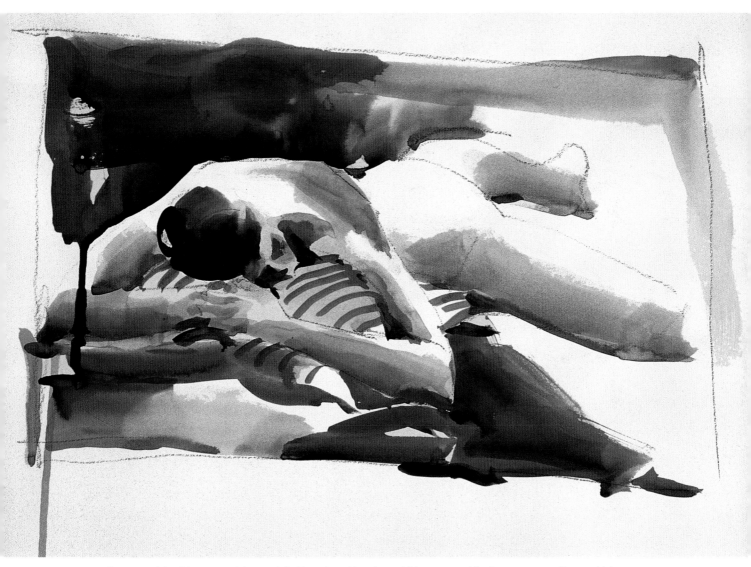

I tempered the light green of the model's skin color with a glaze of light orange while the paper was still wet, which enabled me to keep the luminous look of the wash. At this point the painting could have gone either cool or warm because of the neutrality of the skin tone. With the same brush I quickly dashed in the background in burnt sienna, turning the painting to a warm key. Before I knew it, the next pose was struck, forcing me to stop and turn the page over the top edge of the table, which resulted in the paint drip. I kept it anyway.

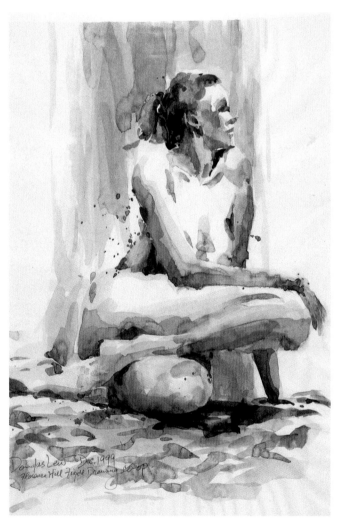

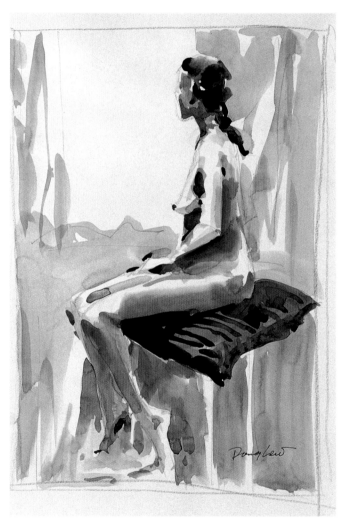

I liked the pose immediately and stretched it from a twenty-minute pose to about forty since I continued to paint even after the model had started another pose. I started with the head and, once I saw that it was good, proceeded with the rest of the figure. Since the pencil line was already there, I skipped the coffee break and continued with the same pose. The verticality of her upper body contrasts with the horizontal emphasis of her bent leg, giving the pose solidity and interest. To increase the feeling of solidity, and keep her legs from floating about, I added some little broken folds of the sheet beneath her.

By now you've probably noticed the same pillow reappear in many of the paintings. The models love them. They're big and soft, yet dense, and are perfect to sit or lean on or be propped against. I liked the simplicity of this pose and the effect of light flooding in from the window.

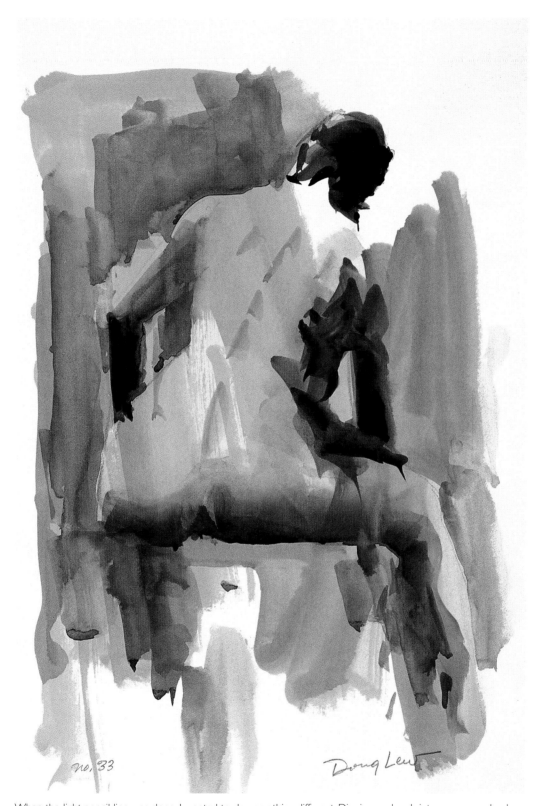

no. 33

Doug Lew

When the light pencil line was done, I wanted to do something different. Dipping my brush into a generous load of raw sienna, I impetuously started the wash from the left and, in horizontal strokes, applied a swath right across the body that ended at the right side of the page. I didn't know where I was going, except that I was aiming for an integration of the body and background. I knew the yellow falling on the body was not true to the skin tone but I let it happen just to see where I could go next. The large flat yellow was so bold I quickly defined the body with shadows under the two arms, though perhaps a bit too darkly. The nice result was the surprise shock of the big yellow strokes, but I learned a hard lesson: I should always form an intent before I begin.

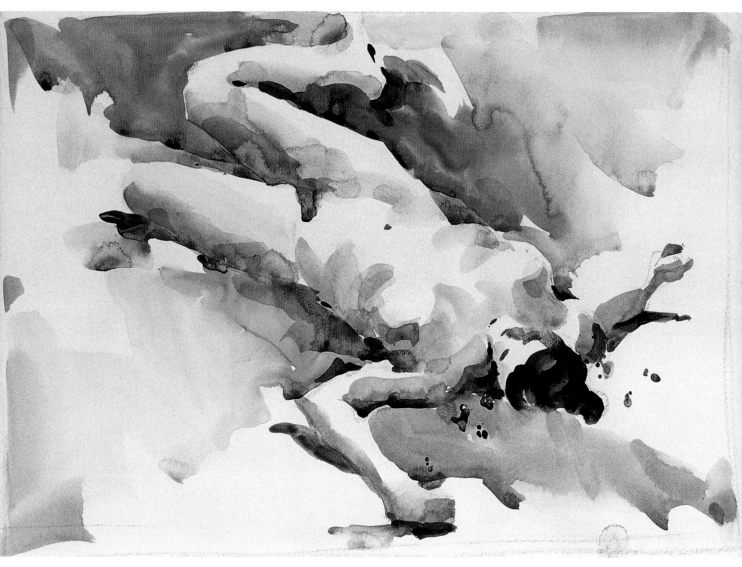

The skin tone was neutral bordering on the cool side, which led me to create a cool background around the body largely following its reclining direction. I used the turquoise to the right of the body, and a little on the left leg, to kick it even more to the cool side, but also to maintain the mint-fresh feeling of the whole thing. The sparing use of red and orange added a bit of juiciness to the painting.

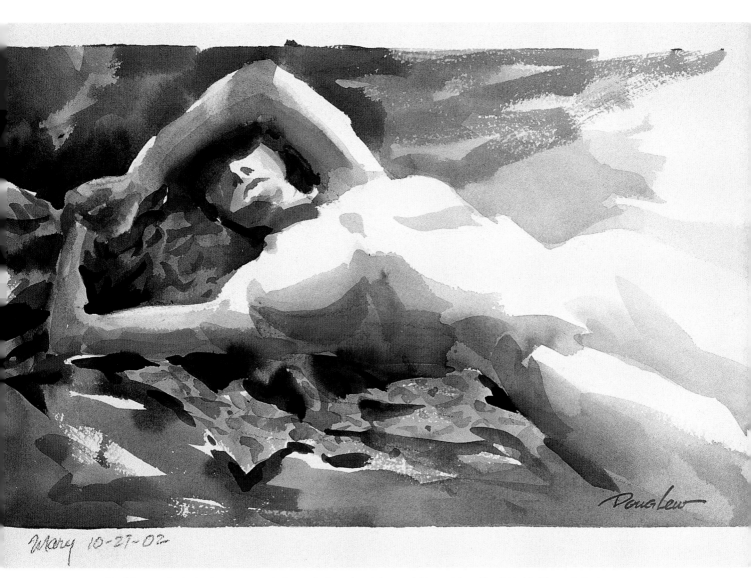

Mary 10-27-02

For this pose the lost edges were carried even further, almost to a vanishing point on the right side. The cast-shadow under the model's left arm that covered the eyes gave the whole thing even more of a sense of mystery.

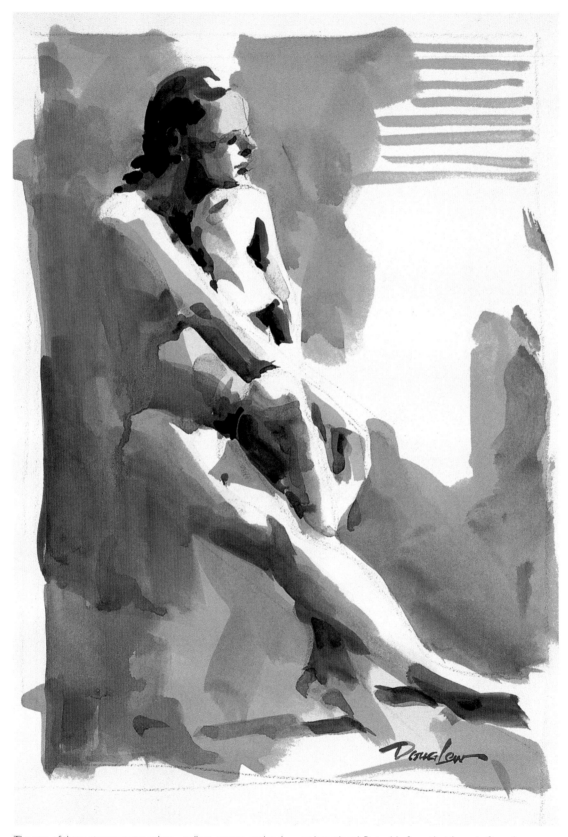

The use of three strong warm colors—yellow, orange, and red—was intentional. But aside from that, I went after a larger area of lost edges at the left side of the figure to contrast with sharp and dark edges to the right. At the time I was thinking, but only indirectly, about the look of some of Rodin's sculptures in which figures seem to rise halfway out of a block of stone. It's strange how the influence of other artists comes out in one's own work, often in unexpected and unpredictable ways.

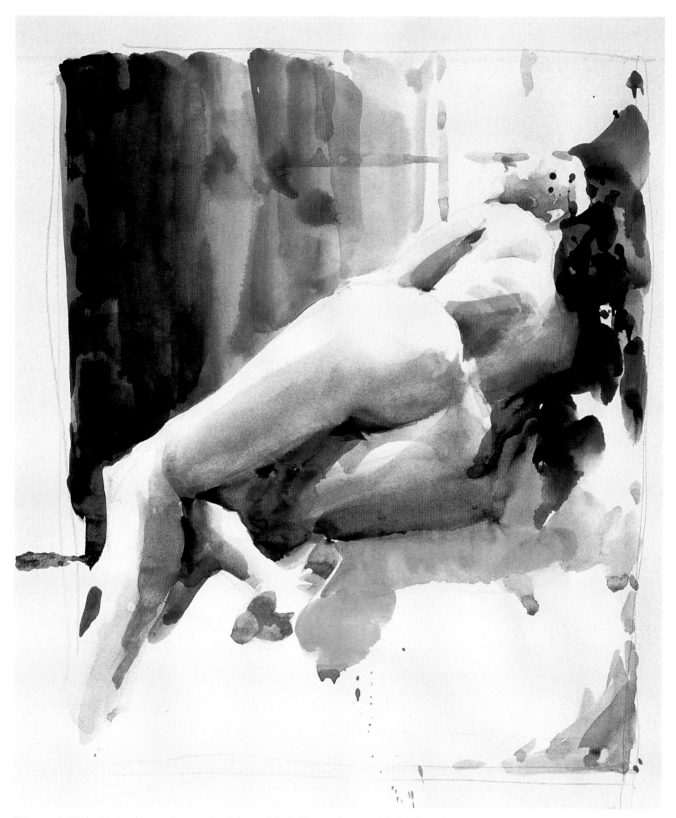

This pose is filled with the drama of contrasting lights and darks. The small mass of dark hair on the model was balanced by a large mass of the same color on the left side, while the strong light from the window blasted in so strongly it fused with the left arm and traveled continuously down the left leg and off the page. The unusual composition leads right into the next chapter.

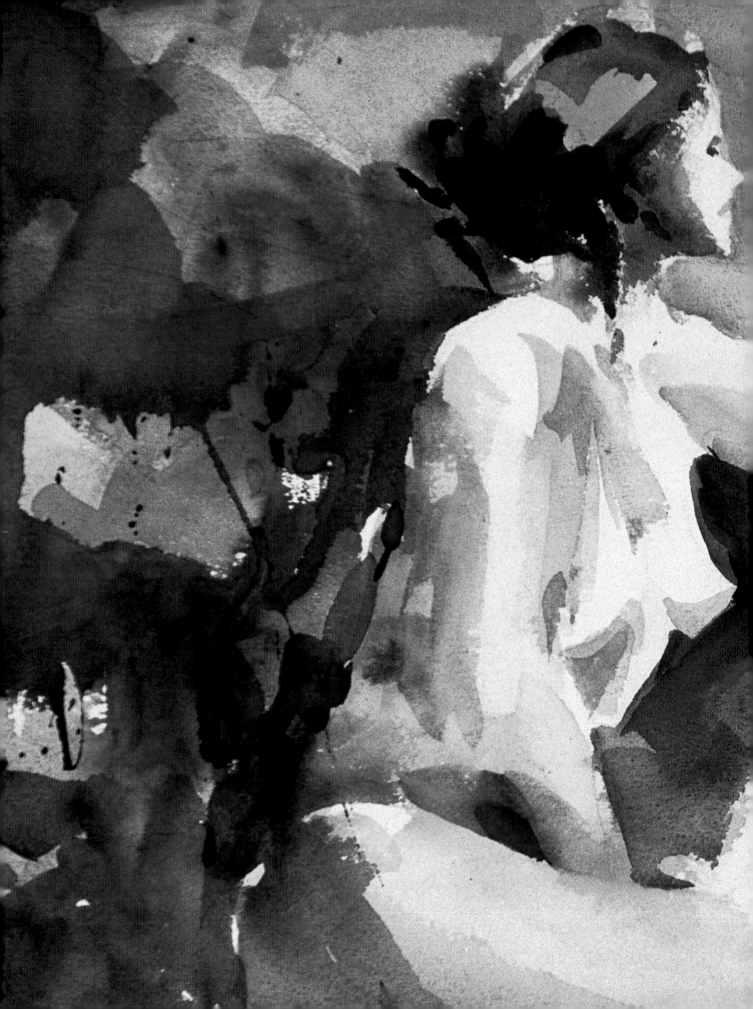

3

*Building
a Painting*

Composing the Figure Within a Background

What is the difference between a figure drawing and a figure painting? Let's assume the figure is drawn on a surface without a background. One can safely say that it's a drawing, a study, or an exercise. When done well, it is certainly a work of art, but it is not a painting. When the model is posed against a draped backdrop with props, a realistic treatment of it would constitute a painting; but when the model is placed in the center of the room on a platform with artists and easels all around, a realistic treatment of the background becomes very difficult. The reality is that a shared studio does not always provide an ideal background for a painting, and you certainly cannot arbitrarily move props around—or other artists!—for a good composition.

I do not think of the shared work environment at the co-op as a roadblock, but rather as a unique opportunity to solve a problem, and to make a painting. You may ask, "Does putting a plain background behind the figure make it a painting?" My answer to that is yes, it's closer to a painting, but it's merely the beginning. A slight shading and shadow in the background behind the model would help. Better yet, you might break up the background into different-sized shapes corresponding to the lines and shapes of the figure. In short, you have to literally invent a background. The challenge then becomes one of integrating the figure with other elements of painting, such as shapes, value, and color.

The Arrangement of Shapes

The decision of where to put the figure and how large to make it is already the beginning of a compositional consideration. A quote from Matisse comes to mind: "Composition is merely an arrangement of shapes and color within a space." The broad stroke of the quote does not speak to all that composition is; however, it does convey the importance of the role *arrangement* plays in this important principle of art. For instance, if you place a full-standing figure smack in the middle of the page, you are left to consider the space around it. *That* is the big question! If the figure assumes a different pose—such as sitting, squatting, or reclining; arms bending or outstretched; legs crossed or straight; waist bent and head tilted—what do you do with the irregular space around it? Very often I see a painting that is very well drawn and with good colors, but somehow there is something uneasy about it. Chances are the composition is poor, or the figure is poorly placed within the given space. Poor drawing is like the poor foundation of a house; poor composition is like the poor arrangement of rooms, ill-fitting and dysfunctional.

About Lighting

Light is another consideration. It controls the distribution of value—that is, of light and dark—on the figure. Many life-drawing studios pay too little attention to light. Often window light is supplemented by artificial lights pointing in all directions, flattening the model and stealing the figure's natural *chiaroscuro,* its play of light and shadow. Indirect light is fine—it tends to make all parts of the model visible since no details are lost in shadow areas. However, a single light source that casts strong shadows will give form and drama to the figure. A single light source can also help you to integrate the background and figure in a way that looks natural and convincing. It enables you to correctly create and place a shape—say, a window, drapery, or prop—so that the light and shadow are consistent with the light source on the figure. Or you can use the light and dark shapes formed by the figure to fill in the background and harmonize the composition in an interesting way. During the short days of winter a session might start with daylight and fall into darkness, making it necessary to use one or more artificial lights. This causes a light shift, but fortunately the poses at the co-op are never long enough for this to cause a serious problem. In any case, if you anticipate a shift from natural to artificial light, it's best to place a stronger light above and slightly to the side of the model, in line with a source of daylight.

The Color of Rubens's Flesh

Having talked about background, composition, and light, let me tackle the most elusive part of building a painting—color. Powerful, emotional, and highly subjective, color defies rules and rejects regulations. It's the freest part of the painting process. When painting from life, the tendency is to paint the flesh as true to the visible as possible. We all do it. We admire the lushness and realism of Peter Paul Rubens's (1577–1640) naked women. We know that for white skin a touch of very faint blue pigment will bring out its pinkish white color. We know that highlights are more prominent on darker skin and that a touch of blue will bring out its chocolate tones. To achieve Ruebens's flesh tone can be challenging and rewarding, but I find that once the color formula of skin is understood, achieving it becomes a bit monotonous. Who says skin color always has to be the same? What if a blue light, or a red, green, or yellow one, is cast upon the figure? Would not the skin reflect the color of the light? After all, a white wall will always reflect the color that's cast upon it. That thought occurred to me after my first year or so at the co-op, partly because repetition has always bored me. Once a skill is mastered and a routine established, I am always ready to try something new. Besides, a different skin color can provoke, surprise, and excite the eye.

The Power of Pure, Saturated Colors

In the quest for something different, I also discovered that pure colors, rather than mixed or muted ones, are more vibrant and lively, and have more oomph. That's not to say that every color used has to be pure. Used judiciously, mixed and neutral tones can enhance the brilliance of pure colors. Yet too much neutral is the quickest way to deaden a painting. Such is the power of color. Having said that, I've deliberately done some figures in pure colors and others in neutral tones, just to compare the effects of both.

I've learned that, in the depiction of the figure, accuracy in drawing is paramount. All artists strive for it, and also to maintain the eye-and-hand coordination necessary for accuracy. But, all things being equal, a loose, fresh color is superior to a deadly accurate and neutral one. When I had my last figure show, the feedback was on how colorful it was, rather than, wow, a nude show!

Losing Edges

During my early days at the co-op, I tried to include the entire figure within the given space of the paper. (Today, if I start the figure and find that it's too big to fill an entire sheet, I just let it drift off, incomplete, or I zoom in on half or three-quarters of the figure. I let the concern for a good composition dictate what and where to leave off. Incomplete edges often produce a painting superior to one in which the figure is complete.) Soon I began to experiment by deliberately losing certain edges. Lost edges are not always successful. Yet, on the whole, viewers have an uncanny ability to connect them in very much the same way they take in an Impressionist painting, in which things are only suggested, rather than spelled out in every detail. Giving the viewer an opportunity to imagine what's missing, lost edges can add a measure of sophistication to a painting and create a far more rewarding experience for both viewer and artist.

Building a Painting

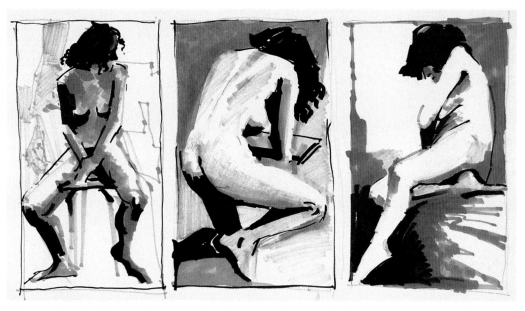

When the idea of making a painting became fixed in my mind, I started with these small sketches, first in black and white. For this suite I used the white of the paper and two markers—number five gray and black—to create three very pronounced values, done without gradations. I drew boxes as an exercise in forcing myself to adjust to the size and to place the subject accordingly. As a painter, I was already drawn to compositional considerations. It's easier to figure out the compositional needs when the space or boxes are small.

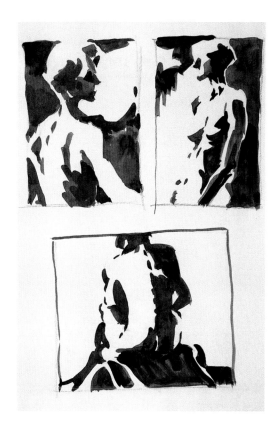

For these three poses I used only the black marker, without any grays, just to see how the composition would hold up. I knew that different colors of the same intensity could be added later, and that I could always soften the edges and refine it with middle values when I started to paint.

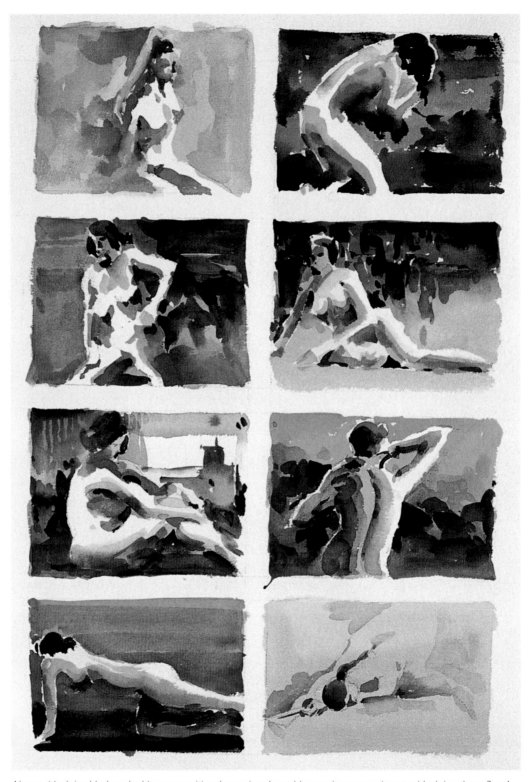

Along with doing black-and-white compositional exercises, I would sometimes experiment with doing these 3-x-4-inch color thumbnails at home, using line drawings done at the co-op as guides. Then I would bring them to the co-op and put them beside the painting pad. When a pose similar to any of the thumbnail sketches was struck, I could use the colors of the thumbnail and not waste time trying to decide what colors to use.

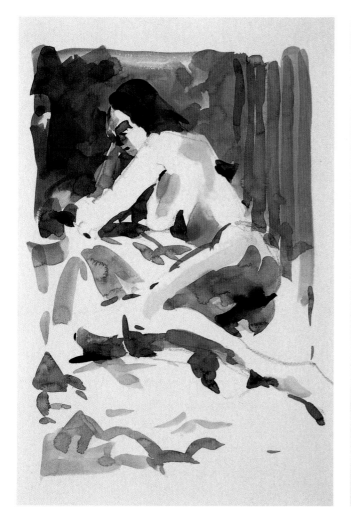 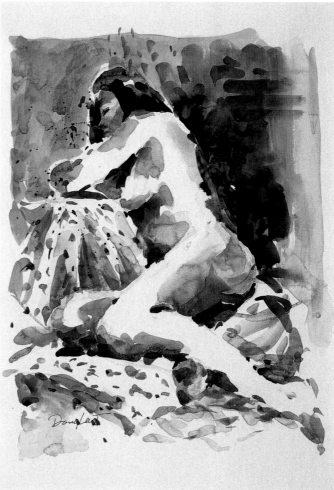

This twenty-minute pose gave me the chance to do two different treatments: first a one-color composition sketch and then a full-color one immediately following. I changed the value on the upper part of the background in the one on the right to allow for a greater contrast in value. I also painted in the pattern of the sheet, which helped to separate the figure from the sheet.

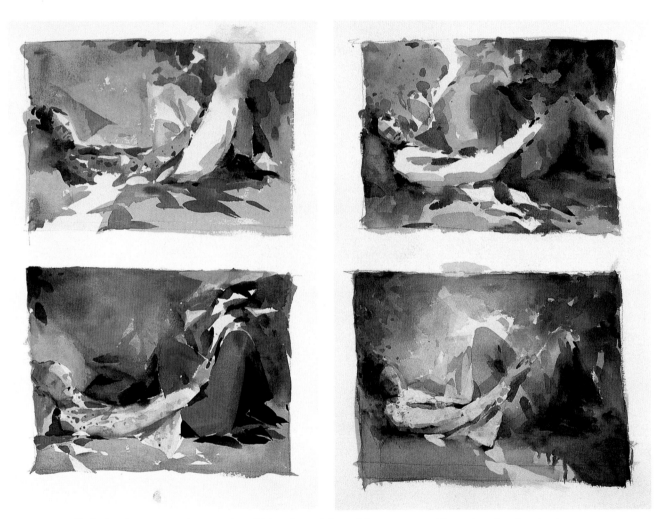

To further sharpen my color sense, I would do color variations of the same pose at home, based on line drawings I'd done at the co-op. Putting simple clothes on the figure gave me the opportunity to use more colors. All of these experiments are my personal aids in making color decisions for the painting on the spot. Not all of them were successful, but they gave me a chance to experiment with color; making a wrong color decision at a crucial stage can be very discouraging.

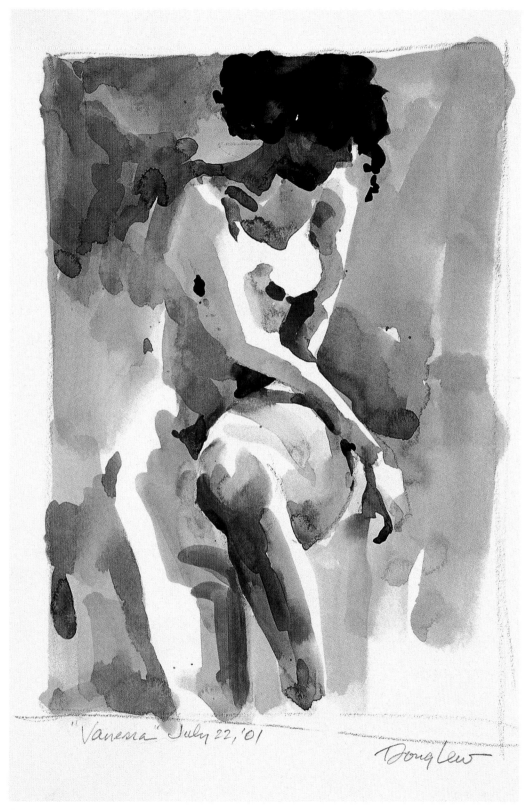

"Vanessa" July 22, '01

Doug Lew

The model Vanessa is a slight, dark-haired Puerto Rican. Her poses were always natural and relaxed, and she was able to hold very still. I mixed burnt sienna and raw sienna for an uneven background and let it move into the body to indicate the light shadows. Looking back, I can't remember why I next used the green to further delineate the body, except that though it looked a bit startling, it did not look unnatural. I do remember putting a touch of manganese blue under her right forearm and a spark of red on her knee to juice up the color.

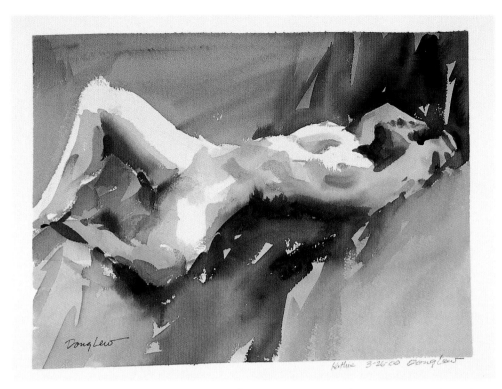

I started with the orange background, outlining the figure with warm tones. I finished the passage bordering the figure with a deep, red cast-shadow under her body. Before the red dried I let it mingle with some grayish blue and carried that down toward the left. The transition looked good and that emboldened me to put in an even darker blue for greater contrast and drama at the upper-right side of the painting. I softened the edge on the left side of that passage to harmonize it with the blue passage below. The background now takes on a diagonal movement from upper right to lower left. I used a 140-pound Arches watercolor paper and finished it within the twenty-five-minute limit of the pose.

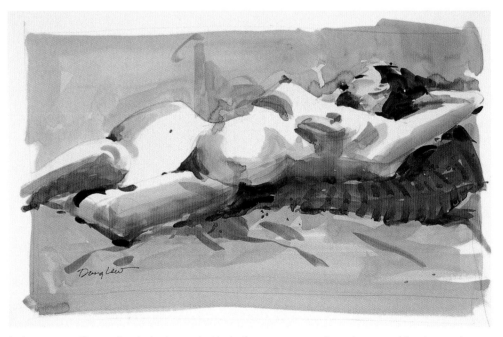

In the process of integrating the background with the figure, you can really get lost, especially when you're working on a large sheet of 18-x-24-inch paper. There seems to be so much space to cover. I was tempted to subdivide the space, play with the smaller shapes, and integrate them with different parts of the figure. Since the figure was drawn large I decided to render the background simply. Once the drawing was finished to my own satisfaction, I experimented with reversing the warm color of the skin with the cooler background just to see if it would work.

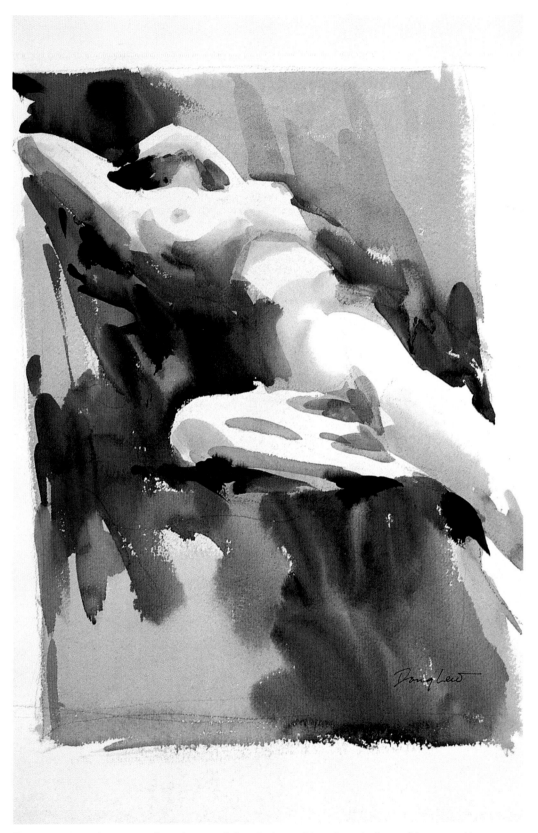

The strong diagonal movement from the upper left to the lower right—the main thrust of the composition—was established by the pose. I accentuated it with a strong blue background moving in the same direction. I didn't want the blue just to outline the figure; I wanted it to be irregular, textural, and vigorous. I think the best part of the painting is the background and a touch of red in the body. The figure was there, but almost incidentally. This painting begins to hint at my later exploration in abstraction.

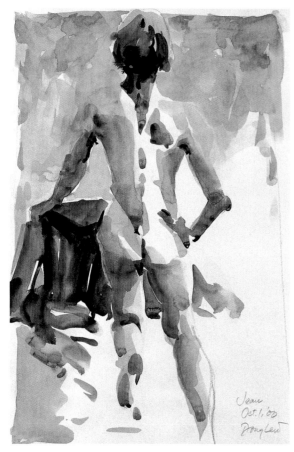

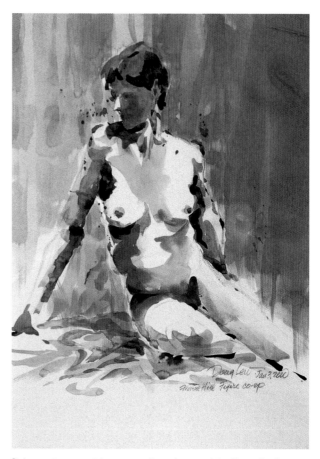

I used primarily green for the body—a strong color, though neither warm nor cool. That gave me the choice either to go warm or cool for the background and the sheet covering the chair. I chose warm for both.

Color and composition are at times inseparable. Since the figure was painted in vivid and contrasting colors I thought it best to keep the background in neutral colors that were opposite the color scheme of the figure. A slightly darker warm gray was used to wash over the gray-blue background. It gave the effect of drapery folds and turned the cool background just slightly to the warm side, though it remained largely neutral. The composition problem was solved with the aid of color.

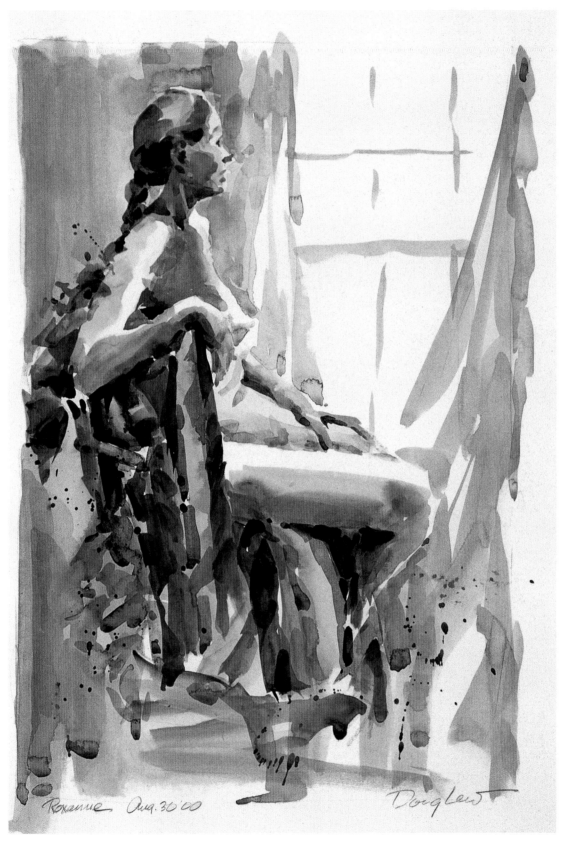

Roxanne Aug.30'00

Douglas

I bought this colorful piece of fabric to work it into this composition. I knew it would provide a strong contrast against the simple background and the somewhat plain figure. I used it with several different models. Eventually the fabric was discarded, never to be used again. Too many artists at the co-op objected to it, perhaps because of its busyness or because it just took too much time to paint the different colors.

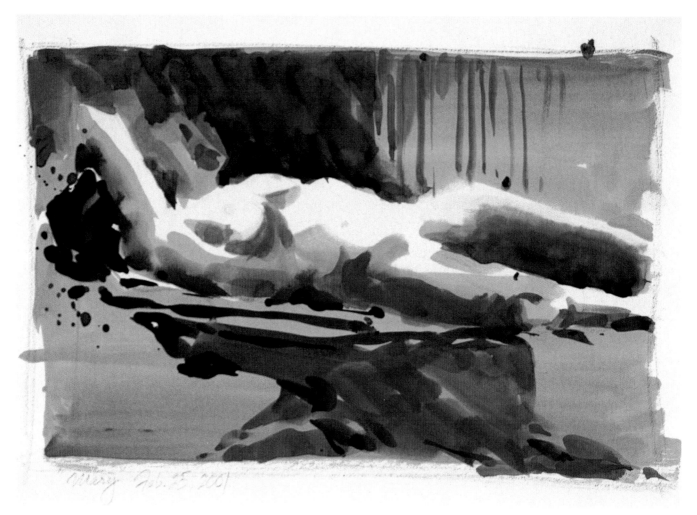

For a change I wanted to try a bright yellow as the key to a whole painting. At first the yellow jumped out so strongly that I had to break it up with some shapes. The red shape under the body looked almost like a pedestal, but it was actually part of an overhanging sheet. I let the dark shape above the figure drift into some vertical lines, purely to enhance the composition.

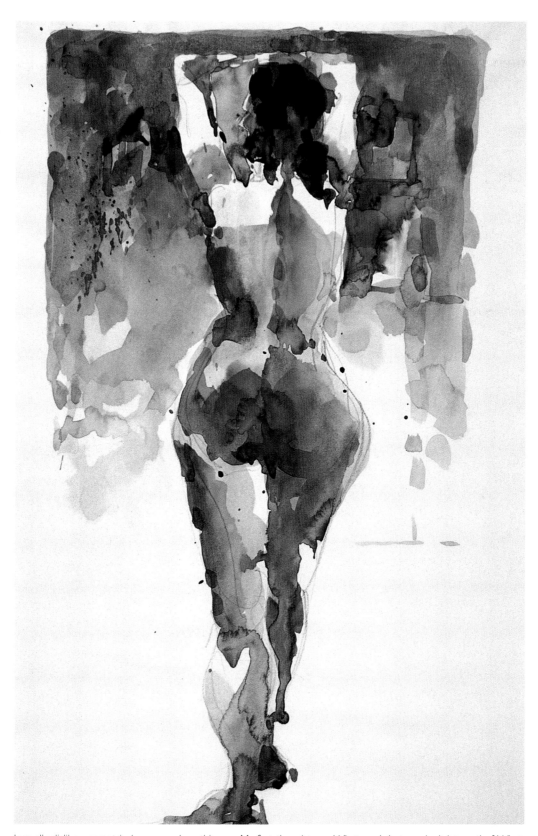

I usually dislike symmetrical poses such as this one. My first thought was, What can I do to make it interesting? What if I use warm and cool colors boldly and loosely in almost equal amounts to break up the monotony of the pose? When I saw the result first in the body, an almost staccato effect, I wanted to fill in the background with the same colors, but only halfway down. I wanted the bottom half to trail off in lighter, neutral tones. Using warm and cool colors served two purposes: to outline the upper body, and to integrate the background and figure in a harmonious yet exciting way.

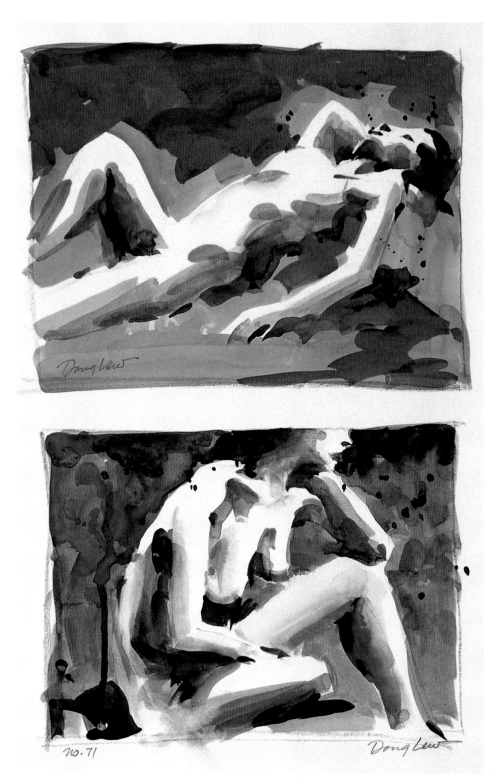

One day an artist friend at the co-op showed me a color called Opera, a vivid and garish pink, so intense that it was almost electric. It was one I would not normally use. But I was in an adventurous spirit that day, so I asked for a squeeze from his tube. I filled in the entire space around the figure with Opera. It was so loud it almost raised goose pimples on my back. I immediately toned it down with some alizarin crimson. Keeping within the warm family of colors, I then rendered the figure in yellow and orange with a touch of light cerulean blue. It looked good. The bottom figure was also painted with a spirit of abandon. I started the background with viridian, toning it down with indigo, and changed it to raw sienna at the bottom. I finished the figure with a combination largely of cobalt blue and fuchsia, and accented it with dots of orange and red.

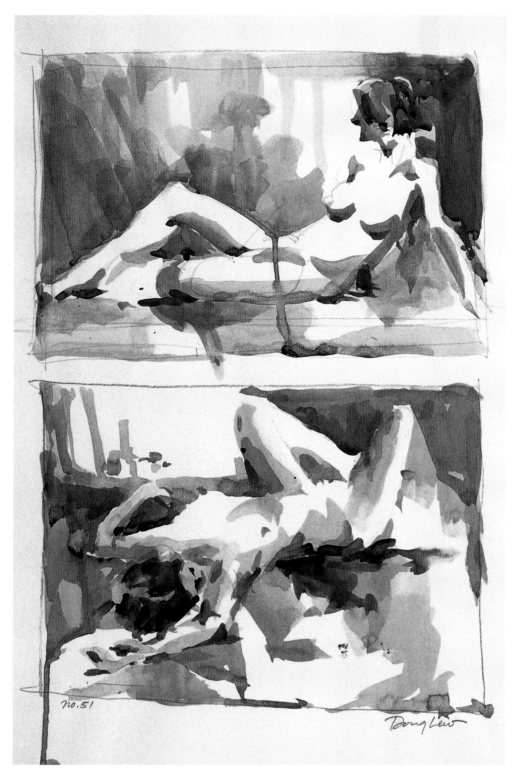

no.51

Dong Liew

These two quick sketches were done with a focus on composition and color dominance. Too many different colors in a painting often destroy it, especially when distinctively different colors are used without any linkage between them. I kept the top sketch predominantly cool, but I tried to use a variety of greens and blues for the background. I added a light touch of purple in the body and repeated that color in the background at the left a nd right. The bottom sketch is predominantly warm, with a variety of raw sienna, burnt sienna, raw umber, and touches of alizarin crimson and sepia here and there for accents. Unlike the figures in the previous two paintings, which were boxed in by the background, these two have more breathing room. Open spaces were left here and there, giving the eye a more interesting journey.

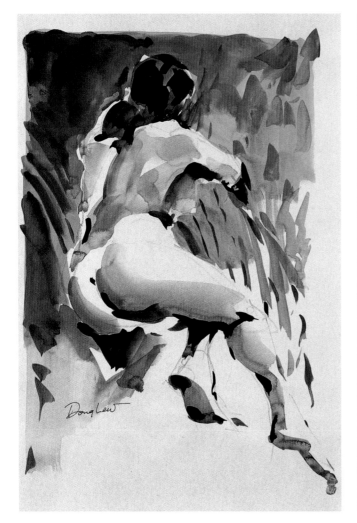

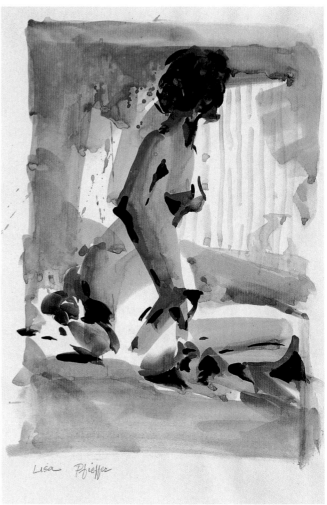

I am by nature restless. At this stage I was preoccupied with trying different colors for flesh tones. I just wanted to see if greens, blues, reds, blacks, or any other color could be used for skin tones and not look odd. These two paintings, and the one opposite, are the result of this experimentation.

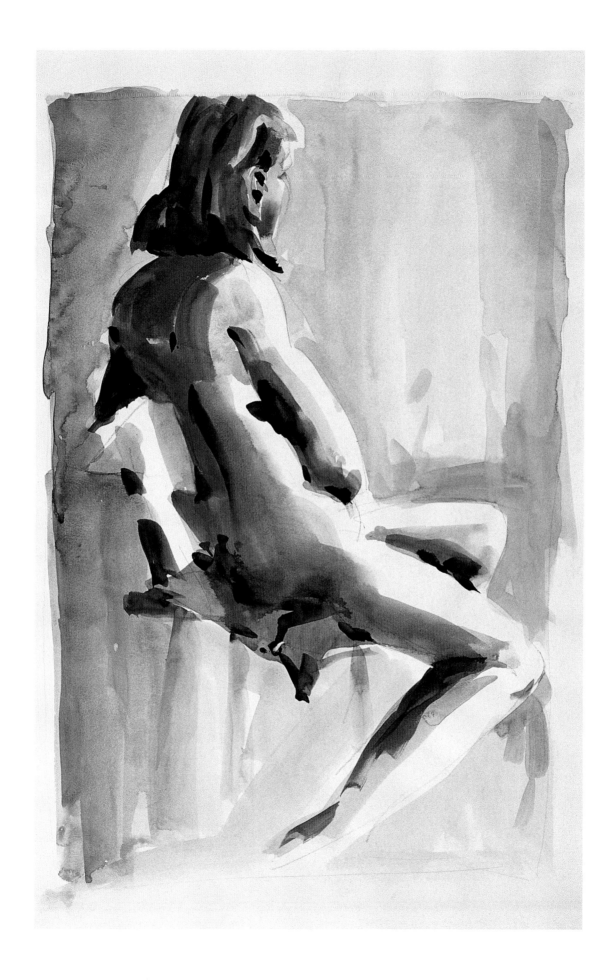

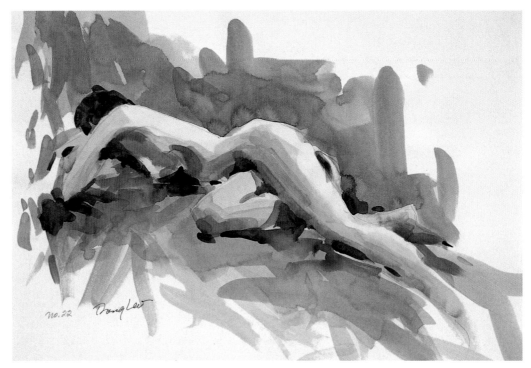

Following my previous experiments with flesh-tone color, I thought, What if the darkest shadow areas on the body were a bright red, the next a lighter shade of orange, and the lightest areas in yellow? I decided to try out my idea on this reclining figure. I proceeded to paint a very faint, light blue tint across her legs while the paper was still wet; the mixture resulted in a light green tone. The colors on the body now looked good, but also very intense; my solution was to mute the warm colors in the background. It gave contrast to the body but also harmonized the color scheme.

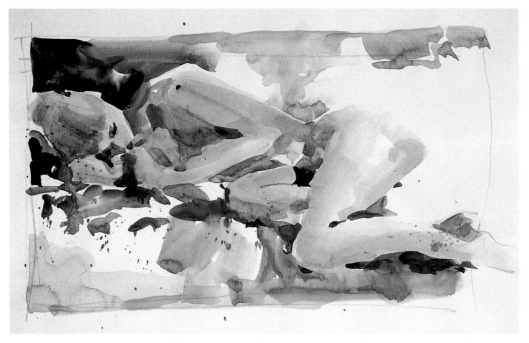

I was caught by the zigzag position of the pose. I was anxious not to lose it, but also to enrich the overall painting with colors that are similar to but different from the green shadows in the body. I spotted in some pure turquoise above the model's head and below her knees to emphasize the zigzag of the pose. To complete the composition I added some red for the pillow and some faint purple here and there for color excitement and balance.

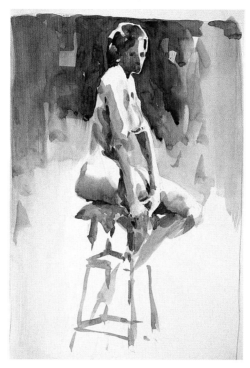

In a painting of color dominance such as this one, I try to use as many different shades of the dominant color as possible, which in this case is brown. The result is a painting with subtle shades of difference, yet the key color is retained. A touch of red and yellow-green on the cushion added just enough opposite colors to keep it from becoming monotonous. Color dominance creates unity; small touches of opposite colors add richness, interest, and excitement.

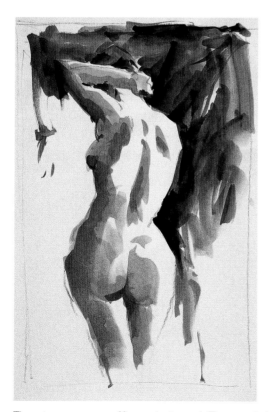

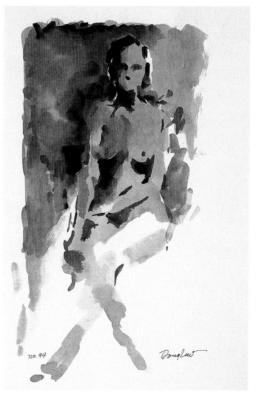

These two poses were fifteen minutes each. They are sketchy and unfinished because I ran out of time. Strangely, I seem to spend more time on the plain, simple poses, mostly to try to make them more interesting either through shading or by accentuating the gesture. So when it comes time to apply color, the pressure forces me to work by sheer instinct—there's not enough time to plan or correct—but sometimes the spontaneous results are satisfying.

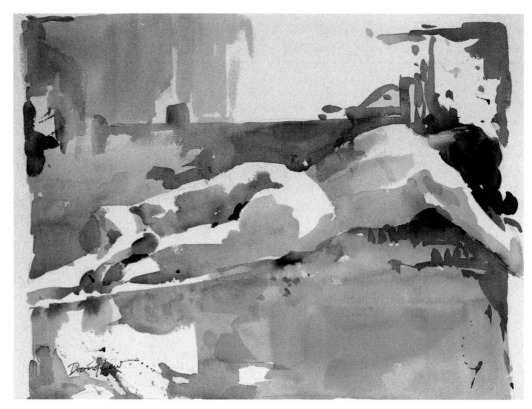

In contrast to the low-key treatment of the painting below, this one was done in high key. I think I was conscious of the fact that I tend to favor contrast, so I reigned myself in on this one to get out of my habit. I learned that in a high-key painting one can afford to have more hard edges without losing the effect of gradation because the change in value is so slight that, if viewed at a distance, the eyes take in the separation almost as a continuous blending.

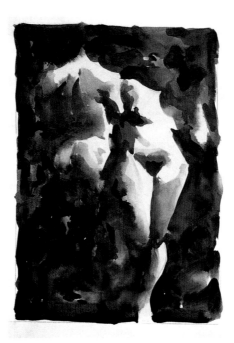

Since the light source falling on both figures was the same and the poses followed immediately one after another, I combined them in pencil and quickly boxed them together. I barely finished painting them during two coffee breaks. By eliminating their heads I simplified the composition—a time saver. At first glance, the dark background of indigo and alizarin made these two interlocking figures look almost like one flat shape, with only the arms separating them. I simply needed to put in minimum shadings to define the bodies. By losing the edge of the left body, it became possible to blend the background into the body. I thought the drama of the light and dark was pleasing.

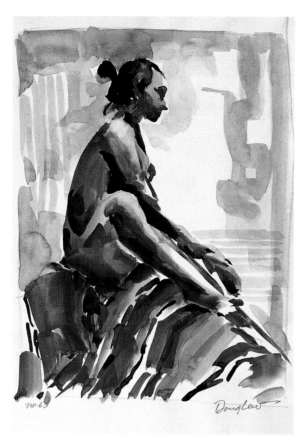

Octavio brought his serape again, so I concentrated on it. During this twenty-minute pose, I spent more time painting the serape than the figure.

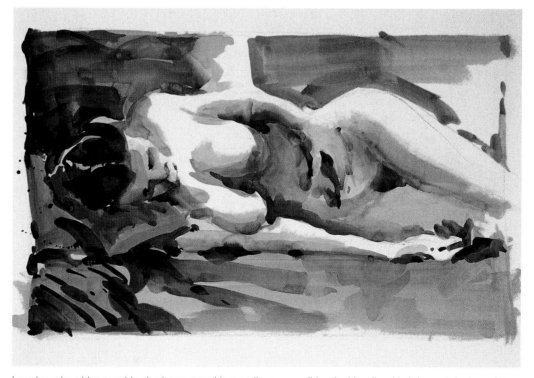

I used cerulean blue to add color interest to this overall warm rendition. I arbitrarily added the cast shadow of the right arm in blue so that the blue in the body was not so isolated. The dark shadow at the model's fingertip was deepened to counterbalance the mass of warm colors on the left side of the painting.

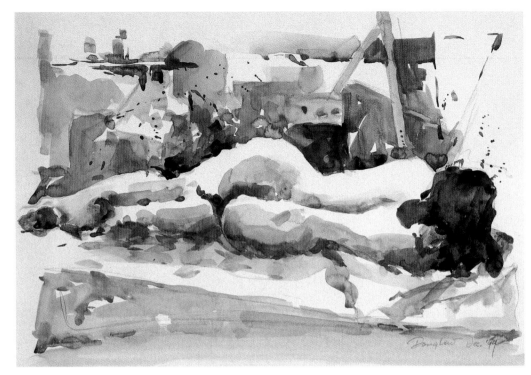

Both of these paintings were deliberately done with busy backgrounds. In the bottom one I borrowed colors from the figure for the background; in the top one I chose colors for the background that would contrast with those used for the figure. By focusing on the interplay of colors between the figure and the rest of the space, quite by accident, these experiments were the beginnings of my foray into abstraction. I began to see that when you play with colors and shapes, the figure becomes part of the rest of the colors and shapes within the surrounding space. In other words, the figure becomes secondary to the overall distribution of color and shapes. In the top painting I was fascinated by keeping recognizable objects a bit undefined.

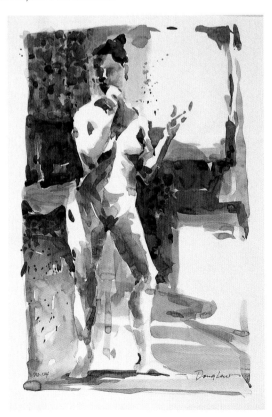

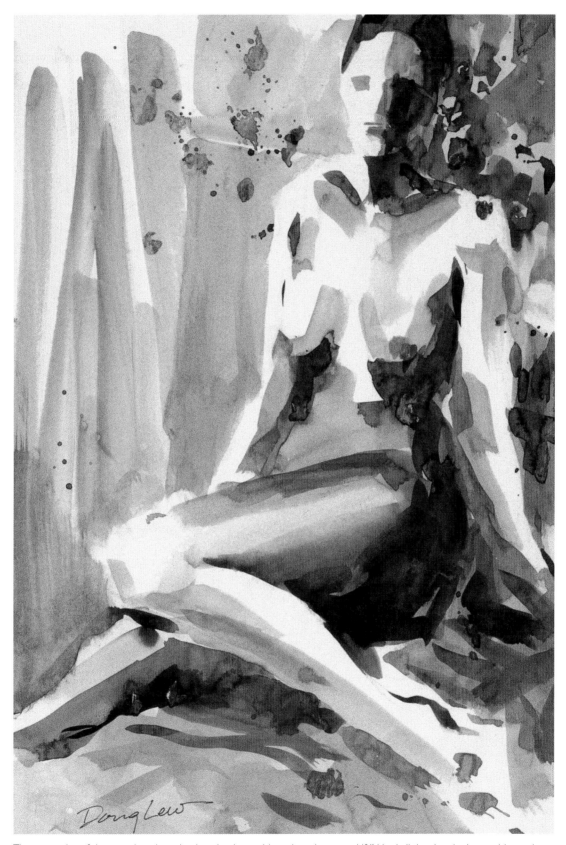

The constraint of time produced results that simply would not have happened if I'd had all the time in the world to paint. The impetuous vertical strokes on the left were pitted against the staccato application of paint on the right. Both treatments came spilling out with no preconceived plan, only intuition. The idea for the dramatic change of color at the bottom came out of the faint warm shadows on the model's body. It worked!

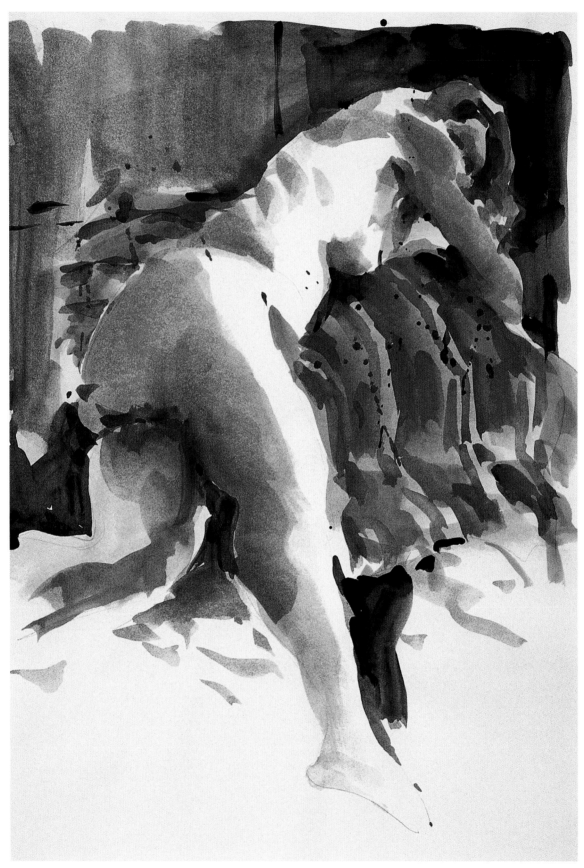

A number of things could be done at the bottom to finish or to enclose this painting, but even before time was up something inside told me to stop, and I did.

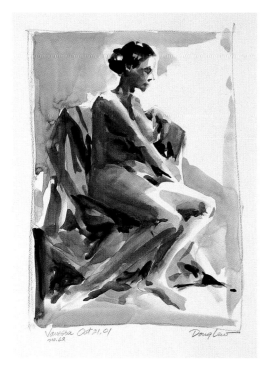

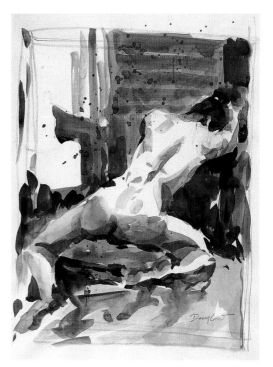

This composition is enclosed by a faint pencil line that I drew in the beginning. I indicated the large green sheet draped across the chair. Something further could have been done to better enclose the figure, but I didn't want to disturb the delicate, pensive pose.

I wanted to render the body as well as I could with as few strokes as I could manage. Once I was satisfied with what I had done, I set out to render the background shapes with equally few, but larger, strokes. Big, wide brushstrokes always contain a certain verve and energy.

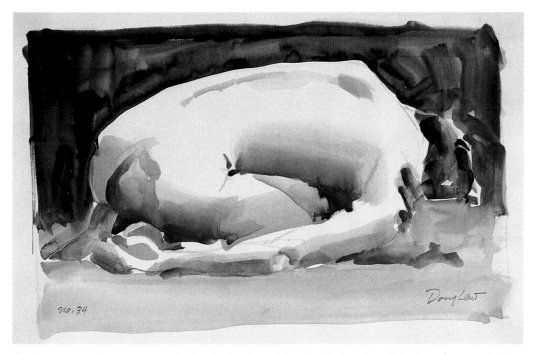

The simplicity of this pose gave me the impulse to do a bold and minimal shading of the figure. So as not to take away the strength of the simple shapes, I defined the arms, hands, and feet just slightly. If the pose had been held longer than twenty minutes, I would have attempted to add more color and texture variation in the same value to the upper background. The visible, wide brushstrokes accomplished almost the same effect of texture and color, except lacking perhaps color excitement. Note that the background below the figure is much lighter and less textured than the upper background. This painting reminds me of what Andrew Wyeth (b. 1917) said once, "When you lose simplicity, you lose drama."

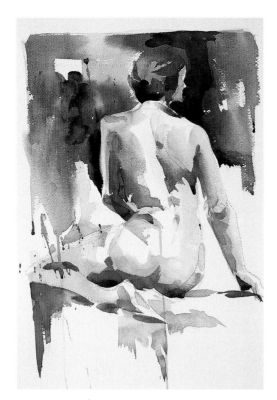
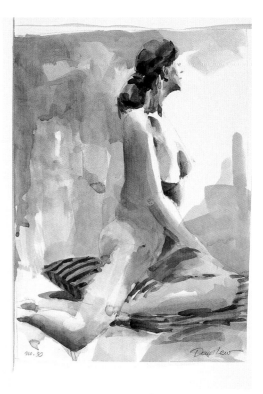

My treatment of these two poses is nearly identical: the main difference is that they have different color schemes. In each I carried the more or less the same colors from the figure to the background. Both have hard and soft edges, and some lost edges, and both have the same quality of paint application.

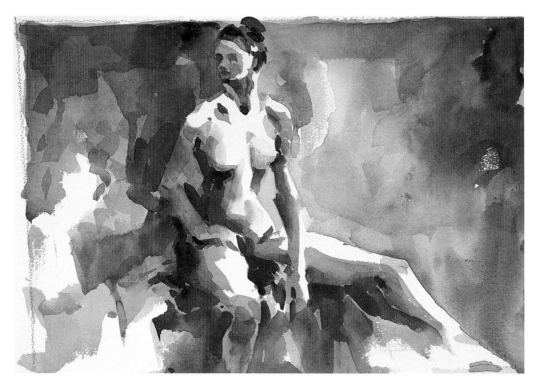

My usual division of figure and background space is about half and half. I had never tried a vertical pose on such an extremely long horizontal space as this one. It presented a tough compositional problem. In the end I thought the color distribution was good, but I wasn't completely happy with how I'd resolved the composition. Perhaps the darkest value to the left of the figure could be bigger to anchor the composition more solidly. Or perhaps simply cropping it would be the best solution.

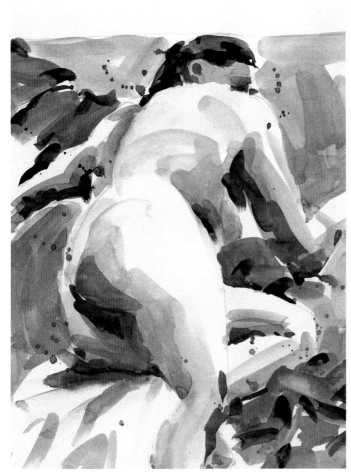

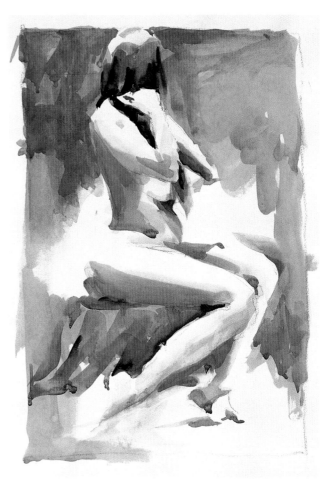

My colorful piece of fabric was used again by this model. I intentionally extended the fabric to the corner on the upper-left side to give direction to the painting and to balance the composition.

I really liked the grace and femininity of this pose. After painting the figure in mauve tones, I decided on a yellow background but varied it by mixing some parts with burnt umber borrowed from the model's hair. I liked the way it looked, especially with some lost edges around her hip and left leg. The colors still looked too separated, so I over-painted her torso and right leg with some yellow. The painting immediately looked better.

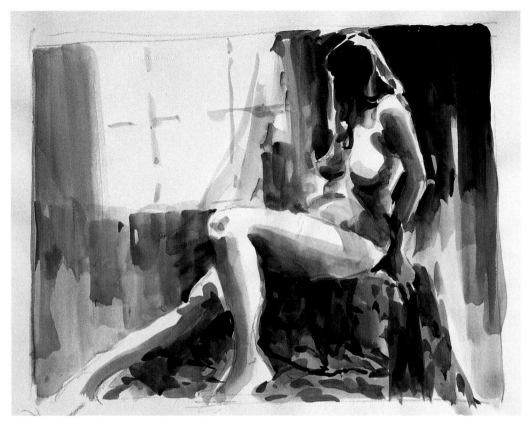

This model does belly dancing on the side. She is sitting on a beautiful sheer wrap that she brought to the co-op for this pose. I liked the wrap and treated it realistically and probably spent more time doing the wrap than the background or the figure. Most of the light came from the window at the left. Additional light came from another window to her right, which explains the rim light around her hair and arm.

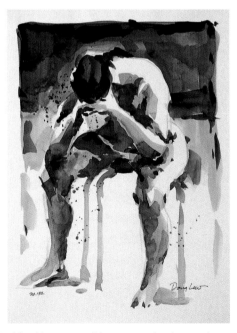

I wasn't sure how much time I had for this pose; catching me surprise, it turned out to be unusually short. I went about putting down the gesture as quickly as possible before it was over, so I dispensed with value gradation. I painted the figure and the background rapidly with flat tones and severely simplified the details. I thought the dancelike quality of the painting came through well.

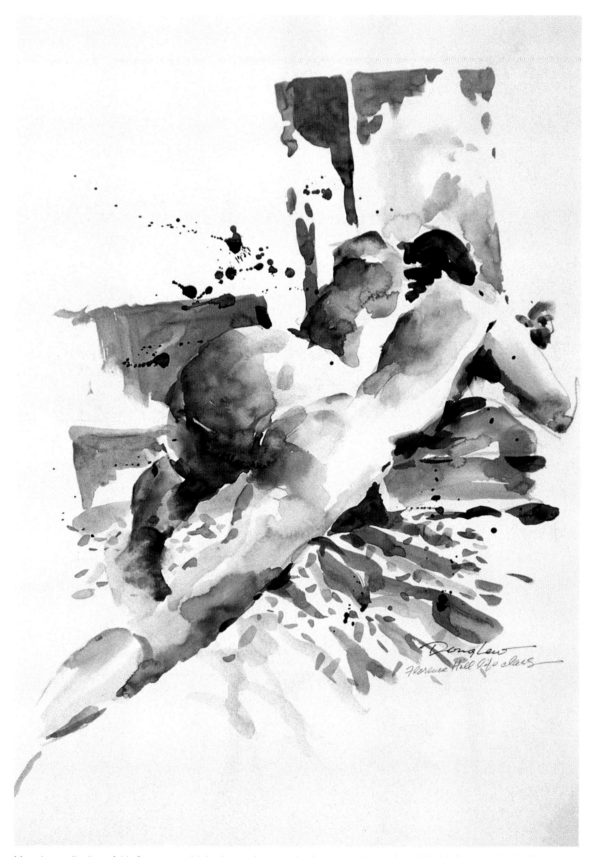

My paint application of this figure was a bit broken and contrasting, but not unpleasantly so. I decided to treat the background in a similar manner—spotty and uneven, and connecting here and there with the body.

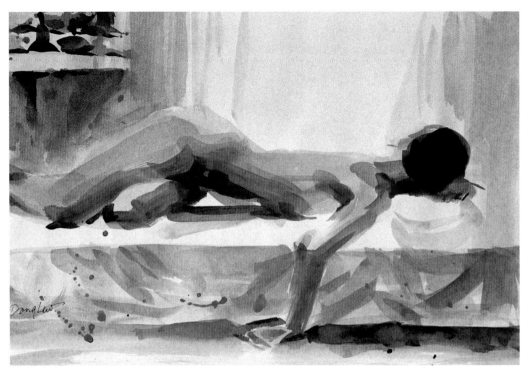

This was one of the few times I painted the entire figure with color closely matching the real color of the model. The color of the figure stood out in bare isolation, so I added the shelf with some indistinguishable objects to better balance the starkness of the composition and to balance the colors.

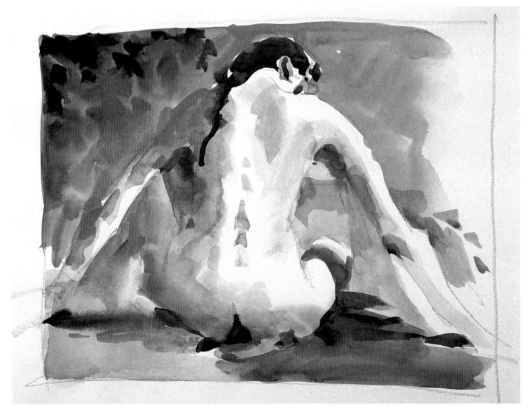

Here the symmetrical placement of the figure presented a design challenge. To keep the composition from being boring, I broke up the symmetry with colors and value. I kept the left side of the figure less defined, losing some edges, until it merged into the background. That immediately broke up the symmetry. The cast-shadow to the right was accentuated to balance the background at the upper left. The right hand was also lost to give more unity to the whole painting.

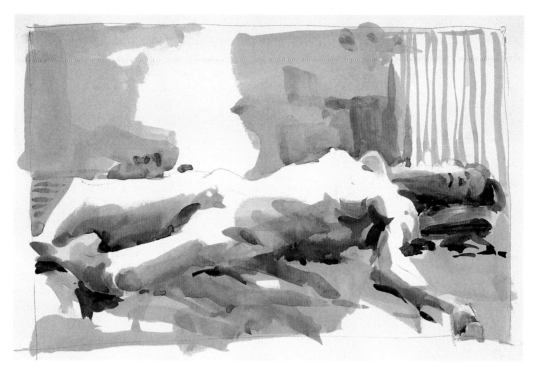

Though this pose continued along the length of the model's right leg, I arbitrarily stopped the length at the slight twisting of her left toe. I then placed the figure in the bottom half of the picture to give more breathing room above the body. The upper part of the design was treated lightly with an open-air feeling. The vertical strokes break the monotony of the upper space and direct the eye to the pillow under her head.

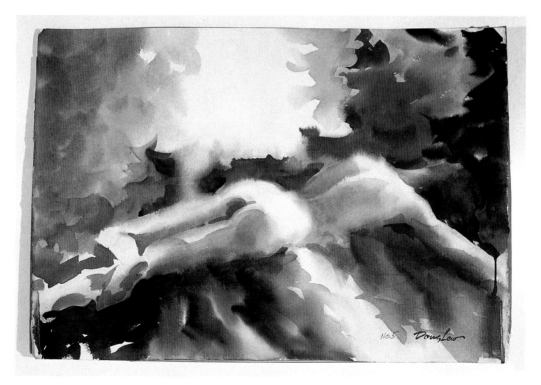

I did this pose at home from my imagination. Not being under any time pressure, I used a regular watercolor paper. I wanted to do two things: to try some pure, saturated, and contrasting colors and at the same time create as many soft edges as I could manage. I wanted to shock myself.

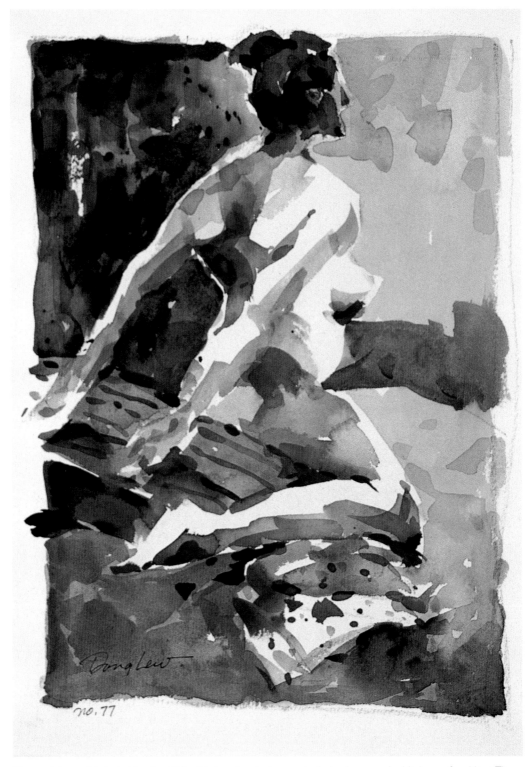

no. 77

The model was able to hold quite still for this twenty-minute pose by balancing on a double layer of cushions. The texture of the cushion served to separate the dark shape on the upper left of the composition, which may be a little heavy. I added the shape extending horizontally from her torso to break up the large pale space on the right. By losing the edge of her right shoulder and breast I allowed the white space to enter into her body, making the organization of shapes more pleasing.

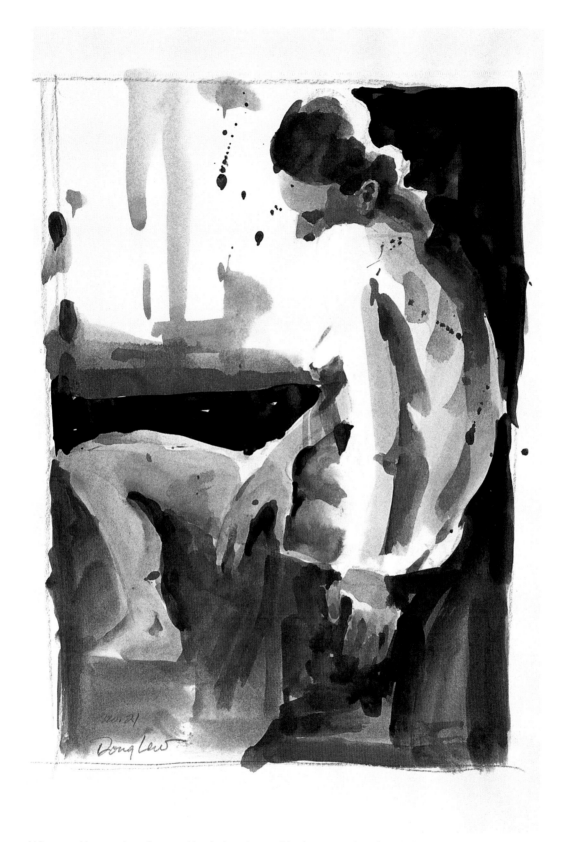

When a quick execution of composition is the primary objective, some minor flaws in the rendering of the figure are inevitable. But in this case I think they were more than compensated for by the strong composition. The white shape from the upper left traveled into the figure without any obstruction, made a ninety-degree turn at the hips, and turned again at the knee. The raised shoulder was defined by the half-hidden face and nothing else. The broad distribution of the brown color was enriched by the barely discernible addition of red, yellow, and blue.

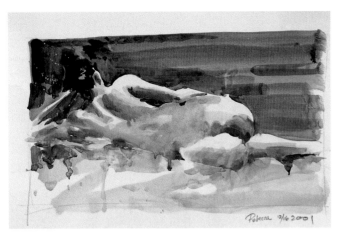

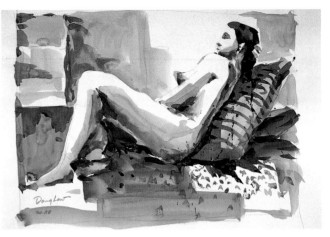

Instead of using a light blue I used a light green to accentuate the flesh tone. My choice of green for the background followed naturally from my treatment of the figure. I varied the green with some yellow, both loaded simultaneously in the brush, then darkened it around the model's dark blue hair in almost the same value. The weight of all that darkness was counterbalanced by the thrust of the model's left arm that supported her head. I tilted the paper to encourage the vertical drippings of the paint below the body to counterbalance the horizontal emphasis of the reclining figure and the treatment of the background above the figure.

When the figure was about to be finished, the darkest passage was the shadow area below the knees. I extended the passage with brown, stopping where the sheet appeared. I then distributed the simple rectangular shapes in more muted colors above the figure, varying the flatness in value. Lastly, I accentuated the pattern in the sheet in order to give some textural difference to the lower-right-hand side of the picture.

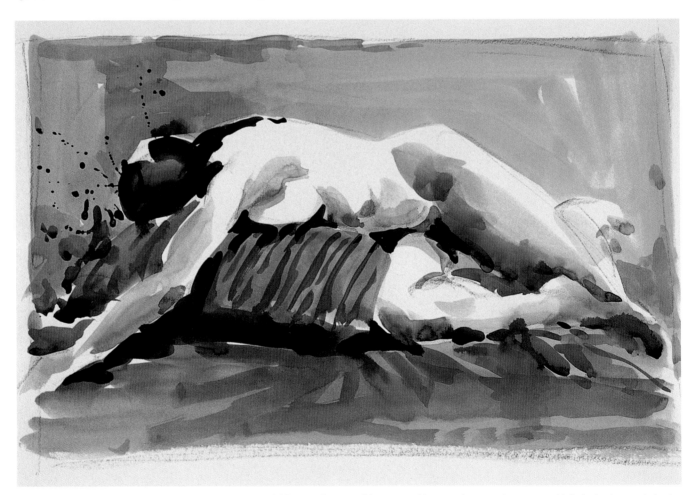

I loved the way the model was draped across the pillow. I didn't want the rest of the composition to take away the pose, so I left the background simple, adding just a bit of green around her head to give it a focal point.

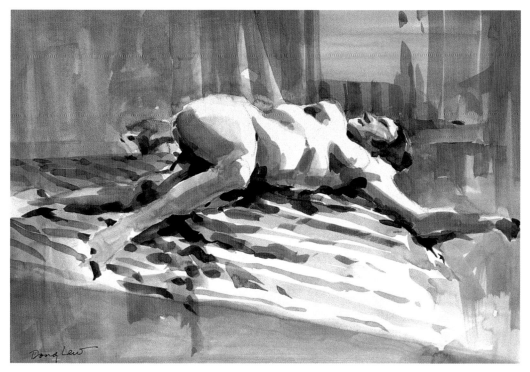

This model is posing on a platform that was intentionally slanted. I wanted to give this otherwise languid reclining pose a more dynamic feel. The stripes on the sheet further energized the composition. The warm color above the figure contrasted with the cool below it. To the right and left of the figure the opposing colors were softly fused.

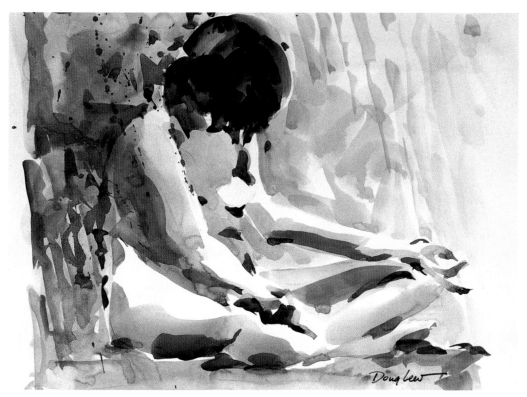

The brevity of the brushstrokes to indicate this yoga position was forced on me, a practical solution to the shortness of pose. I did not have enough time to vary the color within the figure as I would have liked. I was anxious to make the painting as complete as possible by using complementary colors of yellow and orange-brown for the background, but the pose was over before I could move on. The simplicity of my treatment seemed well matched to the yoga pose. However, I wish the colors of the figure and the background were more integrated.

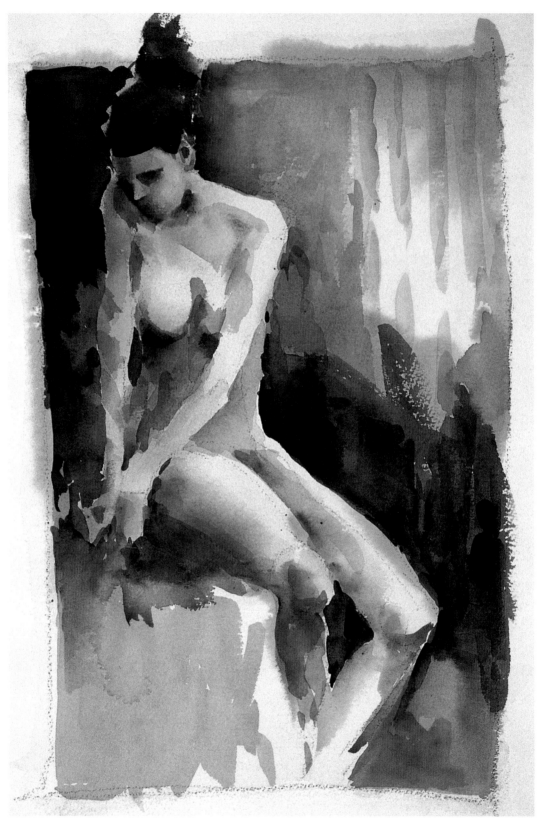

I felt that the interplay of cool and warm colors both inside and outside of the body was harmonious. I was aware of the direction of the body (upper left to lower right) and wanted to accentuate it. The brown color of the background in the lower right was used to trace that direction. It also served to balance the background shape on the upper left.

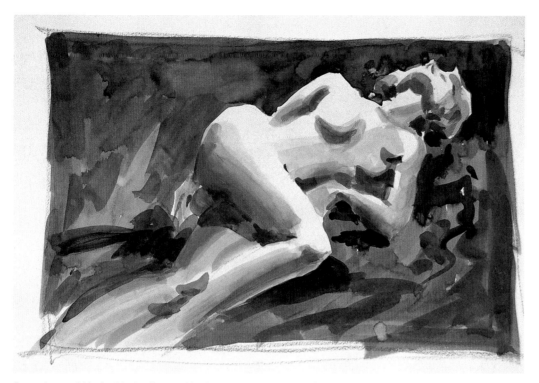

For a change, I blocked in the figure with almost one solid color of green. The only part of the painting left open in the enclosed space was the area where her legs hit the edge of the paper. This created a strong diagonal thrust of the body from lower left to upper right. I decided to leave the painting alone, adding only a faint shade of green here and there on the figure.

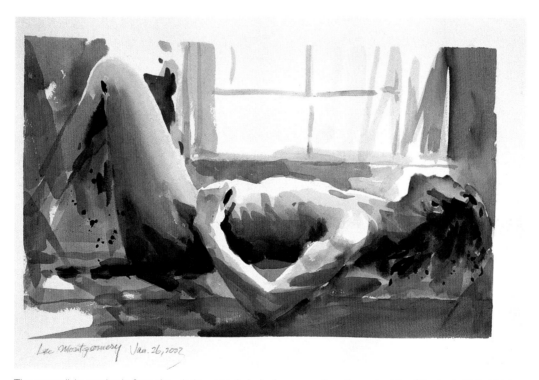

The strong light coming in from the window cast dark shadow areas along the underside of the body. At first I let the light-struck portion of the body connect with the white window but changed my mind at the last second, putting a light gray shade between the body from the window. It actually heightened the effect of the light and improved the composition.

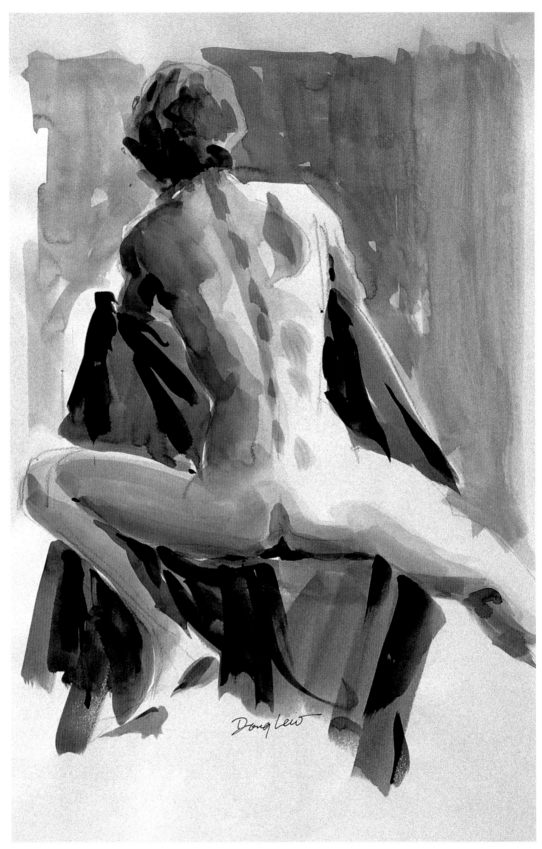

Of all the backs at the co-op, Jean's has always been one of my favorite views. The slight protrusion of her shoulder bones and spine were always interesting to observe and to paint. The background was kept to a light neutral so as not to disturb the prominence of her back.

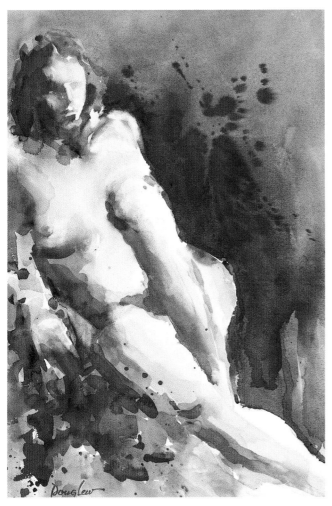

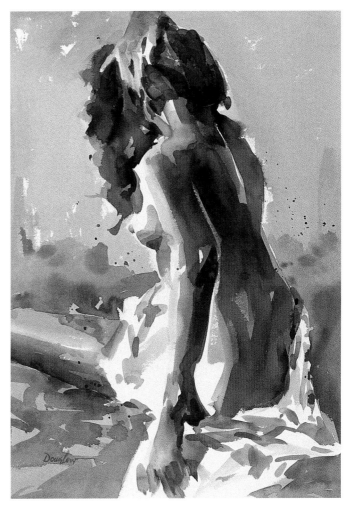

For this pose I first made a Conté drawing to use as a guide. I used a full sheet of heavy watercolor paper to soak up several passages of glazing to get a rich, translucent look. Since there was a lot of intermingling and spattering in the lower left part of the painting, I treated the upper-right corner in a similar fashion to better integrate it as a whole.

I used a charcoal drawing I'd done at the co-op as a guide for this painting, which I later did at home on regular watercolor paper. Since the pose had such a nice rhythm—the dark side of the model's hair, the twist of her right wrist, and the strong shadow on her back—I didn't want to disturb it with anything but a simple background. I made the value a bit darker at her waist to delineate the sheet that wrapped around her. The paint application was loose, which helped maintain the natural luminosity of watercolor.

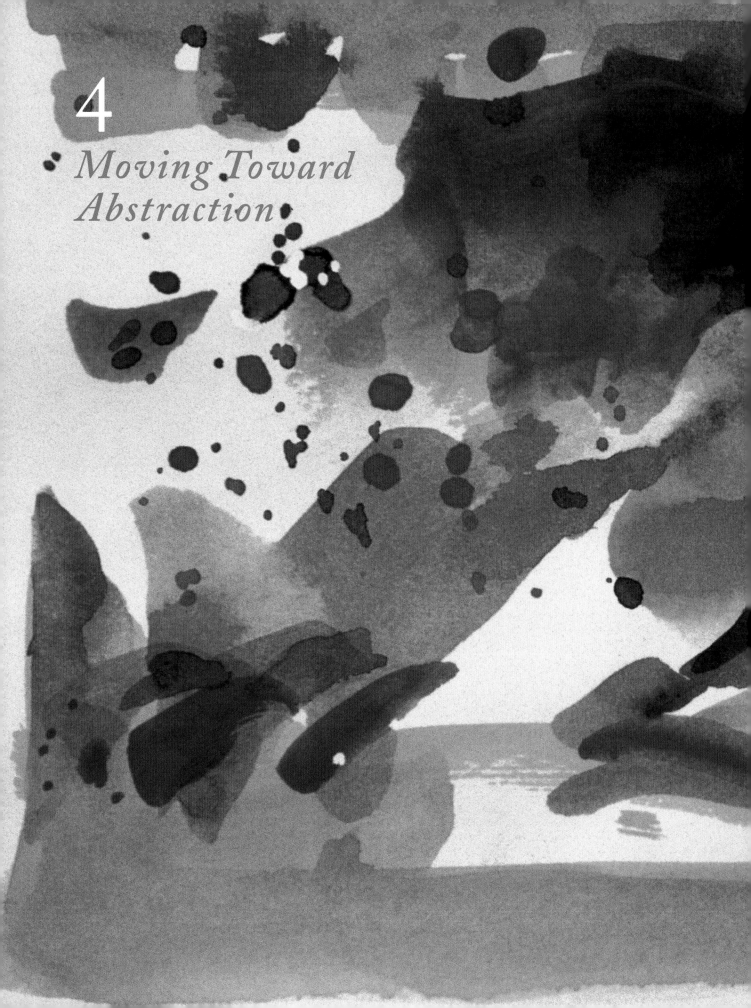

4
Moving Toward Abstraction

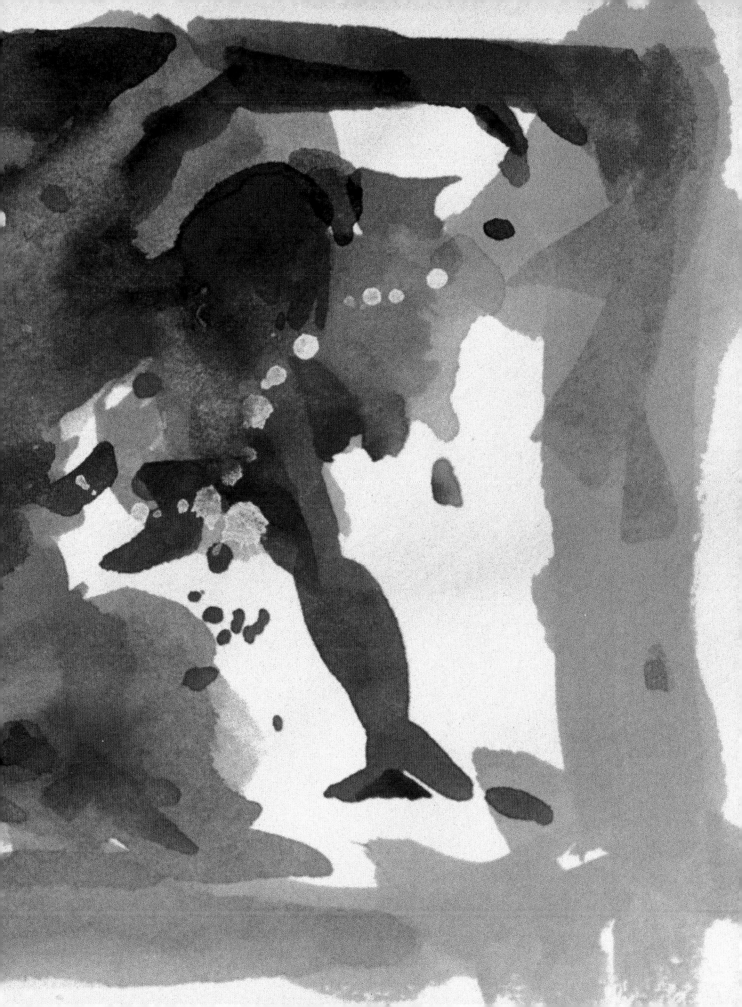

Steps Along the Way

Once I had begun to place the figure within a background, other explorations followed. For example, I began to relate and harmonize the background colors with those in the figure and to form shapes around the figure that I could integrate with it. I began to simplify the figure by rendering it in flat shapes of different colors, and to run colors into each other in a way that alternately described form or flattened shapes.

Not all of these experiments were successful, but some led to an interesting relationship between the figure and background. Other experiments led me to arbitrarily add strokes of colors that had nothing to do with delineating the figure but were there simply to make the painting more interesting. I was excited by the beautiful passages emerging here and there, and they began to point me in the direction of a more abstract treatment of the figure.

Finding Freedom and Variation in Color

Once the idea of abstraction entered into my thinking, it freed me from a realistic rendering of the figure. As if playing a game of hide-and-seek, I took parts of the figure out and put them someplace else, sometimes eliminating all but a visible clue to the figure. Freed from the tyranny of the model, I could now experiment with my color choices. No longer concerned with remaining true to topical colors, I could use the full spectrum of color schemes—cool, warm, high key, low key, monochrome, neutral, high intensity, or low intensity. I could create a scheme in which one color dominates, say cool or warm, but is mixed with different subordinate colors. Or I could ignore color dominance altogether. I could use pure colors, unmixed or undiluted by water. I could follow the basic color principles or break them if I wished, just to see what would happen. I was now able to concentrate on making an exciting painting based on the figure.

Subjugating the Figure

I am not drawn to pure abstractions, though I like them when their colors and textures are pleasing and a composition is done well and is surprising. I confess that I cannot fathom the profundity of the professed psychological and philosophical meanings in many of the pure abstractions. I prefer a semiabstraction in which a hint of something recognizable is present. Personally, it offers me a discipline of intent that I find more challenging. I use the figure as the subject of my paintings and vary my abstraction of it as much as I can. In my early experiments with abstraction the image of the figure came through rather clearly. Gradually it became more faint and less recognizable as my consideration of color and composition took over. I began to create a greater play of light falling on the figure, to alternate the positive and negative shapes within and outside the figure, and to explore the use of unusual and exciting colors.

Despite my steadily increasing experimentation in abstraction, the figure still remained the motif, much like a theme in a piece of classical music that is reintroduced at various points and in various forms. Sometimes I thought of myself as an improvisational jazz pianist. Once the main melody is established, the pianist dances around it and goes off in imaginative flourishes, returning to it occasionally and finally ending with newly familiar notes.

The time constraints of working in a co-op make it difficult to do a semiabstraction on the spot, though it is possible sometimes. To save time I would sometimes do a bunch of thumbnail color abstractions at home and bring them to the co-op to use as starting points. Or I would do small two- or three-value (black-and-white or black, white, and gray) figure compositions at the co-op with the express purpose of using them later at home for making abstractions. At other times I brought home simple line drawings I'd done at the co-op as a guide to play with later in my own studio. However, quite a few of the paintings were done at the co-op, either deliberately or by accident. The ones that were done at the co-op always began with as few lines as possible, just enough to capture the gesture, to leave enough time to decide on the treatment. At this time, during my early experimentation with abstraction, it occurred to me that one can use any subject—a dog, a house, a mouse, a clock, a horse, a shoe, a cow, anything—as a theme in a series of abstracts.

Creating Push and Pull

Unlike realistic paintings, some of my abstractions are devoid of forms that help the viewer recognize things. When recognizable forms are absent, the eyes look for other things of interest created by shapes, line, value, and, most of all, color. The fascinating thing about color, particularly in abstractions, is that it has the power to push and pull the eye. Let's say we have before us an abstract painting that has an even distribution of shapes and values. When a darker, or more saturated, color is applied somewhere in a painting, it will appear as though you have pushed that part down with your thumb. The surrounding part will swell like a balloon. And if a still darker value is added somewhere else, the same push-and-pull effect will occur, yet even more strongly. I learned that flat shapes can push and pull, rise and fall, advance and recede without the help of light and shadow modeling.

Flattening the Dimension

Painting with flat shapes is certainly not new. We are all indebted to Picasso and Matisse, masters of making magic with flat shapes. Their paintings are so strong, I can close my eyes and see their work with almost painful vividness. Flat shapes force the artist to deal mostly with two major elements of art, color and composition, and to a lesser degree texture. The absence of light and shadow removes the three-dimensional effect usually associated with recognizable

objects. A silhouette of flat shapes can, of course, define recognizable objects, such as a paper cutout of a person's profile, but it's a rather primitive way to depict something. My approach to flat shapes derives from the figure and is inseparable from it. Where I've used soft edges, forms begin to emerge, but they can still have a strong sense of abstraction. In the process of flattening positive and negative shapes, I discovered an interesting interplay between them. Alternating between the two, both inside and outside of the figure, led to a lost-and-found effect that confuses, but doesn't obliterate, the presence of the figure. Therein lies the interest—an invitation for a closer look to find the figure.

Maintaining the Theme

It's important to me that the color and composition in a painting is strong, surprising, and inviting. But it's equally important for me not to lose the figure altogether; I find no pleasure in simply splashing around in beautiful colors and interesting shapes to no purpose. That's probably why I prefer an abstraction in which the presence of something is still recognizable. I like to work within the confines of a discipline—complete freedom often results in chaos. This idea—the value of constraints—is beautifully expressed by the composer Igor Stravinsky (1882–1971):

> My freedom will be so much the greater and more meaningful the more narrowly I limit the field of action and the more I surround myself with obstacles. Whatever diminishes constraint diminishes strength. The more constraints one imposes, the more one frees ones self of the chains that shackle the spirit.
>
> (Stravinsky, *Poetics of Music in the Form of Six Lessons*)

I want to create a pleasurable yet elusive feeling where, upon first glance, viewers know the figure is there yet cannot recognize it; but they can participate in, and be entertained by, the discovery of it. Though it may take only a moment, that sense of discovery, I hope, will invite another look on another day. Owing to its infinite variations, I am grateful to have found the figure as the theme of my abstractions, but I'm certain it can be done with another subject in other countless ways.

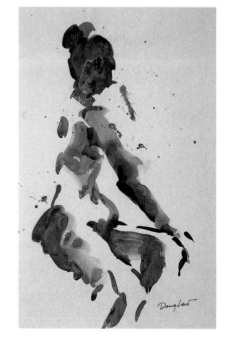

This one was done about midway into my development at the co-op. It was meant to be a very quick gestural indication with warm and cool colors randomly placed. The faint abstraction was an accident, though I liked the result at the time. I made a mental note of it.

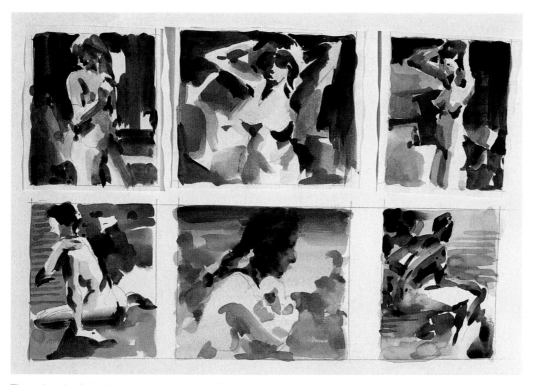

These thumbnail sketches are examples of my first conscious attempts to create semiabstractions. The figure is still fairly prominent.

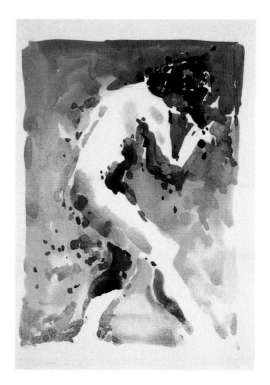

The splashing of the colors also started to accentuate the sketchiness of the figure and to give it an organic, or uncontrolled, feeling. The splashing of the colors, as opposed to a deliberate and careful application of paint, is a way to give a work a certain looseness—what I like to call a "controlled accident."

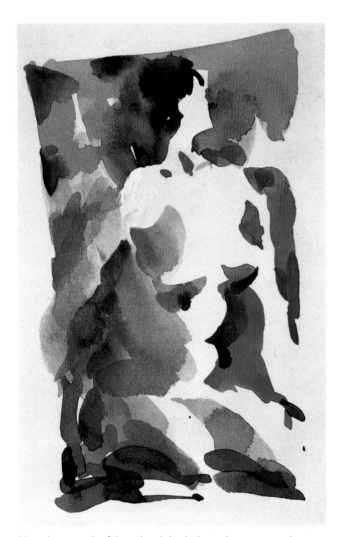

Here the strength of the colors is beginning to be more prominent than the figure.

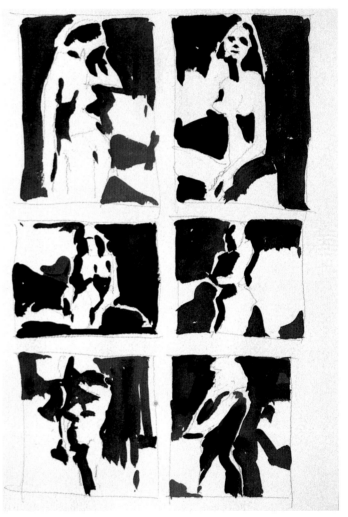

I continued my struggle between clarity and abstraction in this thumbnail, and experimented with the interplay between the positive and negative shapes inside and outside the figure. These two rough examples were done on a 18-x-34-inch sheet.

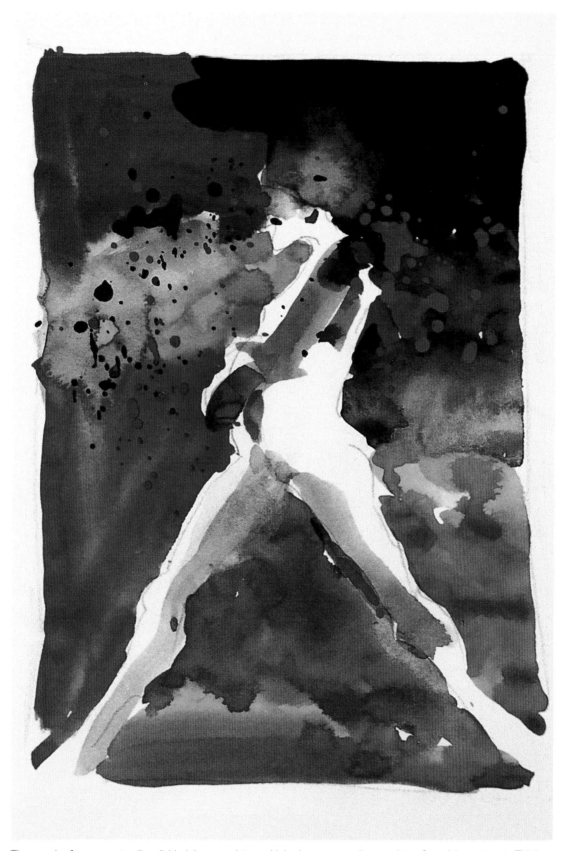

The way the figure was standing divided the space into multiple shapes, suggesting a variety of possible treatments. This is just one way. For example, you could invert the darker passage from above to below, or move the darker passage on the right side of the painting to the left.

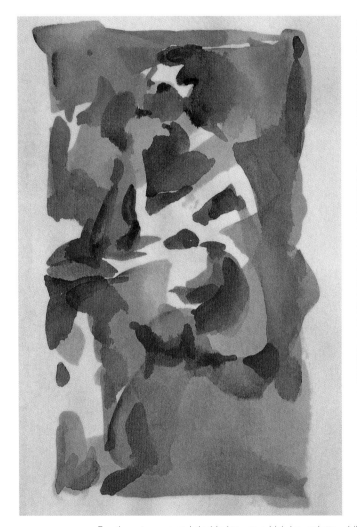 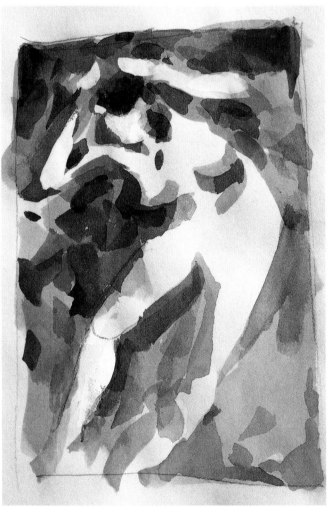

For these two poses I decided to use a high-key palette while keeping the color temperature on the warm side. In the one on the left, the figure, though visible, is starting to blend into the background since the same colors are used to indicate both the figure and the background. Though the colors are still on the warm side in the pose on the right, the stronger contrast of colors makes the figure more prominent.

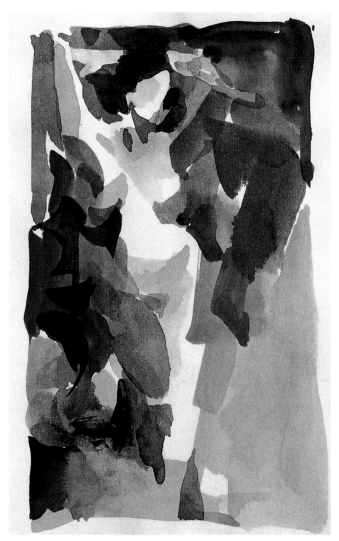

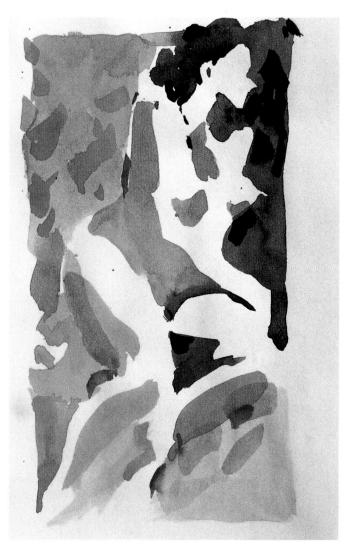

Here I wanted the colors to punch as loudly as possible.

To add contrast and delineate the figure, I used more saturated colors and darker values on the right side of the painting. On the left, the figure was more obscured since the color values are more equal in intensity. Yet the figure is still visible.

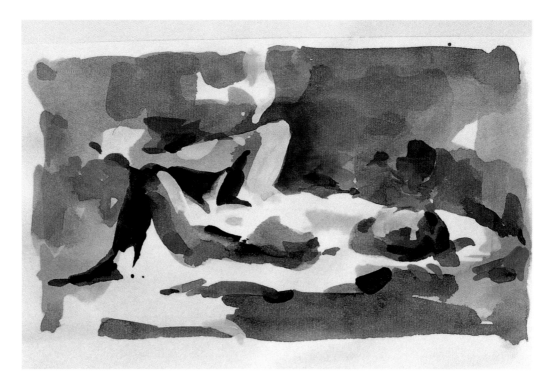

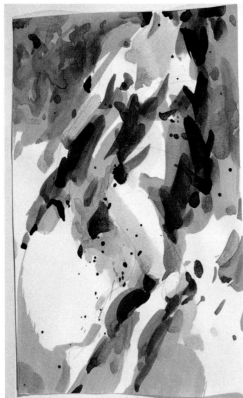

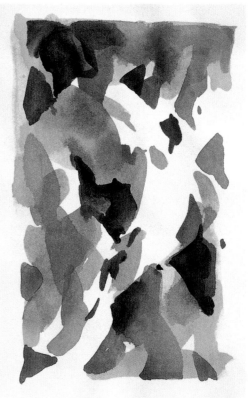

For these three poses there was no blending of soft edges. Every shape and stroke was painted with hard edges. The figures are now less distinguishable and the paintings more abstract.

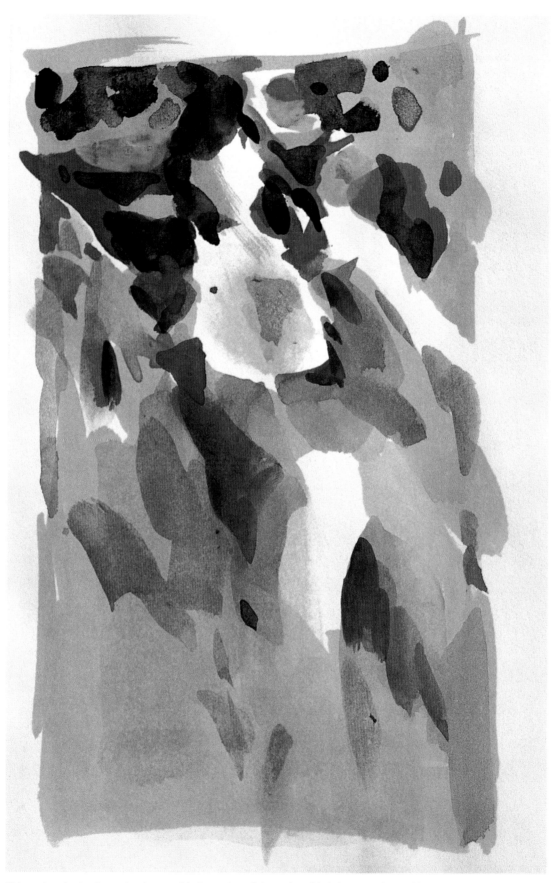

This exploration in abstraction began with the notion of alternating slightly between the positive and negative shapes, as shown by the two arms.

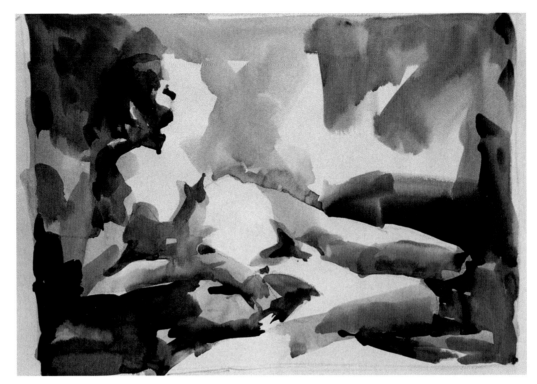

As a relief from the strong pure colors with which I'd been working, I decided to do this pose in a limited palette. When you diminish your use of color, you have to rely more on value to differentiate shapes. It also gave me an opportunity to sharpen my skills at value organization and shape distribution.

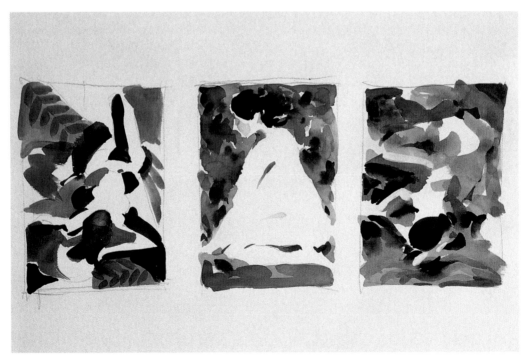

I made these small watercolor sketches at home based on drawings done at the co-op. I wanted to explore the possibilities of using flat shapes only.

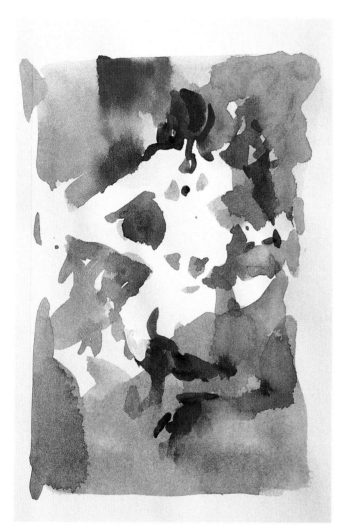

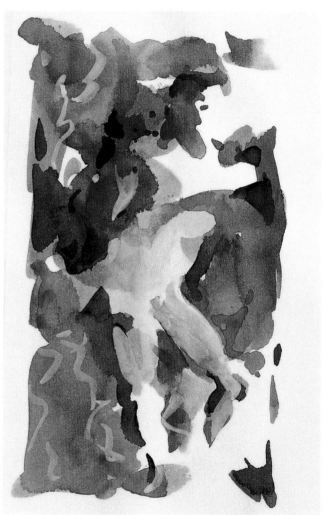

Still experimenting with colors, I tried a more fluid, wet-into-wet rendering of the background with colors fusing from cool at the top to warm at the bottom. It's possible to create this effect using drawing paper when it's done on a small scale, about 8 × 10 inches. (Doing a wet-into-wet treatment on a large scale would require a regular watercolor paper.)

My initial intent was to lose some edges and to create some open spaces along the edge of the paper. My second goal was to achieve some kind of interesting color distribution. The curved opaque white lines at the left-hand side were put in last to correspond with the undulating pose of the figure.

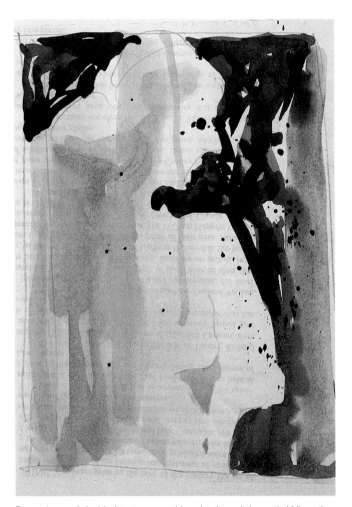 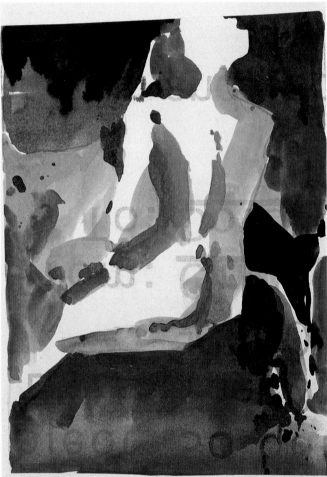

For a change, I decided to try something simple and dramatic. When the model turned to reveal this profile I grabbed the opportunity. A feeling of space and contrast usually offers drama. I felt I needed to contrast the large flat silhouette of the figure against a small dark space that's broken up with some texture.

I keep some paper that's partially printed on one side for the purpose of abstractions such as this one. It offers an interesting juxtaposition of the freedom of the brush with the rigidity of type. However, I try not to overdo this method for it would quickly become mannered and repetitious.

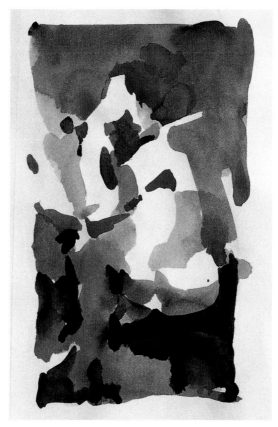

Soft and hard edges were combined and applied to both figure and background. I intentionally decided to work with purple and its adjacent colors. The vividness of this color combination was a treat for me.

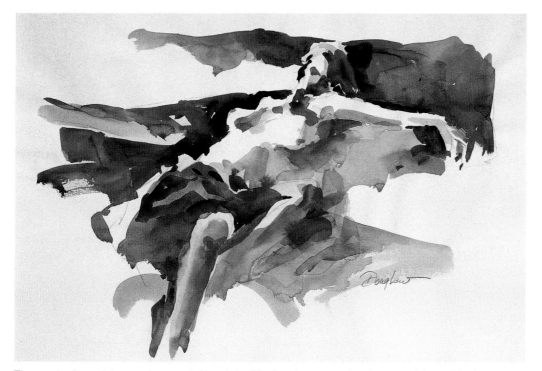

Three main diagonal shapes crisscrossed this painting. The first shape started at the upper right, outlining her arm and connecting her head. The second one started at the neck and moved diagonally in a straight line to the left while outlining her torso. The third shape picked up the second one and crossed her body to the right more or less in a straight line.

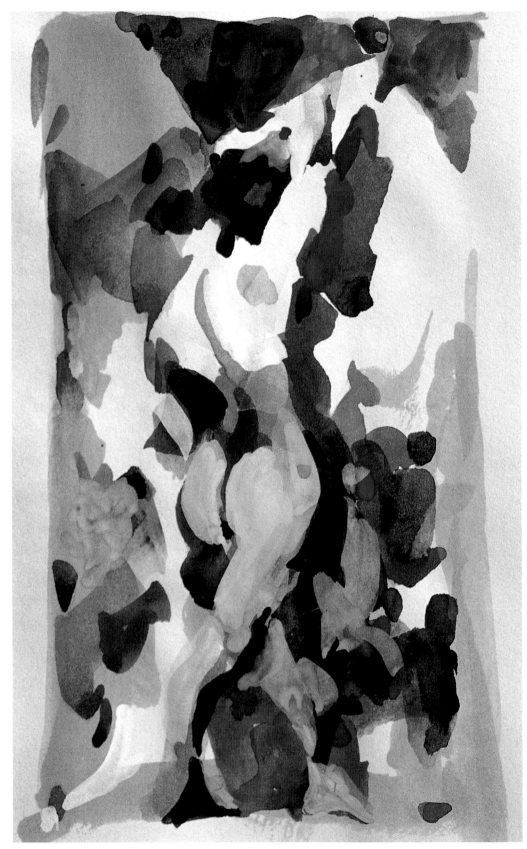

The shapes are flat with hardly any soft edges. The darker shapes at the lower right are derived from the body; they continue upward, outlining the figure. The disbursement of white inside and outside the body not only harmonized the abstraction but also prevented the body from becoming too obviously outlined, thus losing the abstract quality.

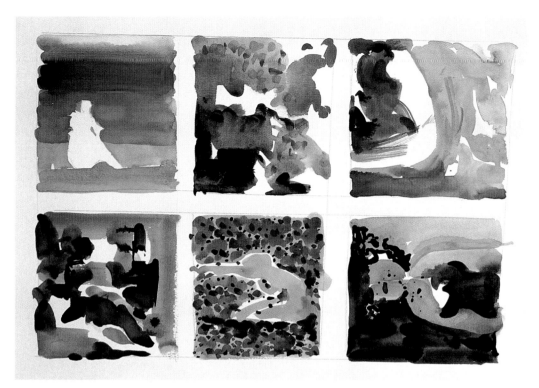

By the time I did this thumbnail I was well into my abstract-experimental stage. I was torn between clarity and obfuscation—I just couldn't decide how clear the figure should be. These thumbnails were done more as a struggle than as an experiment.

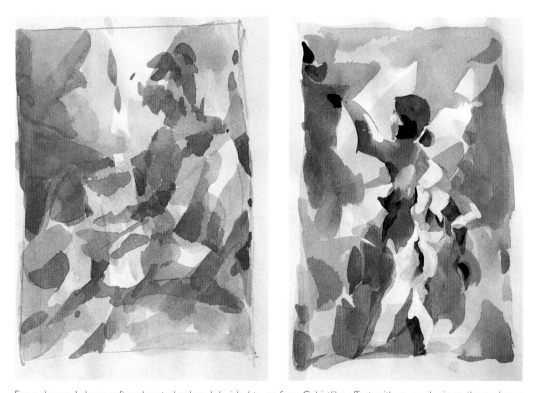

For a change, I chose soft and muted colors. I decided to go for a Cubistlike effect, with an emphasis on the exchange between background and figure.

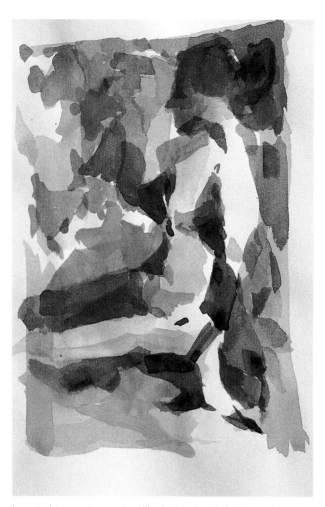

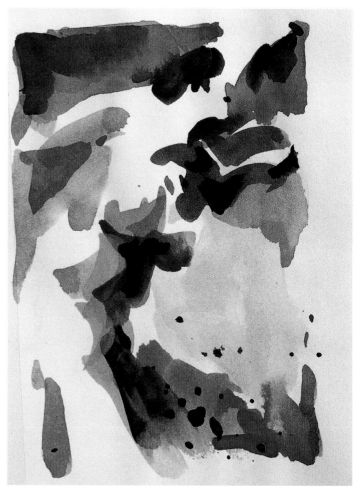

I wanted to create a patternlike look, yet with just enough uneven repetition to keep it from becoming monotonous. I never underestimate the power of white, especially when it's surrounded by darker colors. So I added additional white shapes outside the figure and made the face dark so that it would melt into the background to help obscure the figure. It also improved the organization of the shapes.

For this one I used a simple line drawing I'd done at the co-op as a guide. I repositioned the body slightly to the left to make room for a more interesting play of colors, while trying not to make the figure too obvious. The main purpose of this painting was, however, to do an exercise in theme variation on the color of brown. I used burnt umber, burnt sienna, sepia, raw sienna mixed with cadmium red, and alizarin crimson mixed with raw sienna.

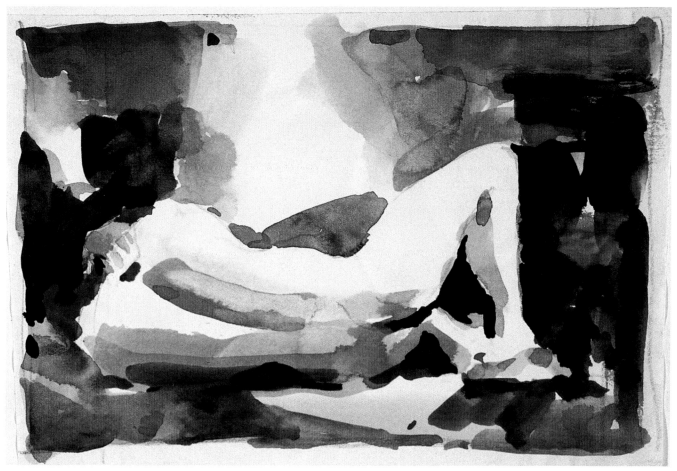

Picasso once said, "There is no such thing as an abstract painting. One has to start with something." I thought about his words as I began to paint this pose. After outlining the figure, I immediately obscured her hair with a dark brown shape. I lightened the brown slightly and extended it farther up to the upper-left side. Then for balance, I repeated the same color under her back and lightened it with some burnt sienna and a touch of indigo. I then extended this shape to the lower-left side. I modeled her back and hips with as few strokes as I could with a diluted tint of the brown. Up to this point the composition was promising but the figure was not recognizable; but as soon as I put indigo on the right side and between her legs, the figure jumped out, perhaps too clearly. Everything else I did was done solely to improve the composition—such as leaving white areas to balance the figure, adding the gray on the upper right for a more solid composition, and dotting burnt sienna around her hair to relieve the dark brown. The light brown patch above her waist was added to delineate her body. I thought that the muted colors worked well, the shape distribution was good, and the white areas were particularly strong.

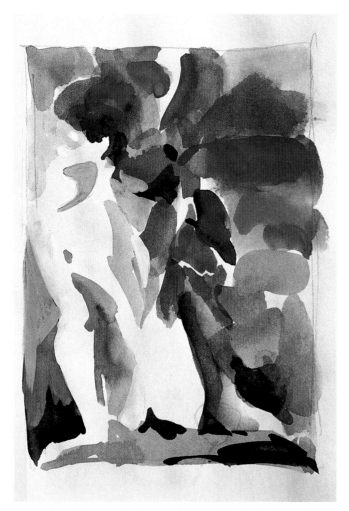

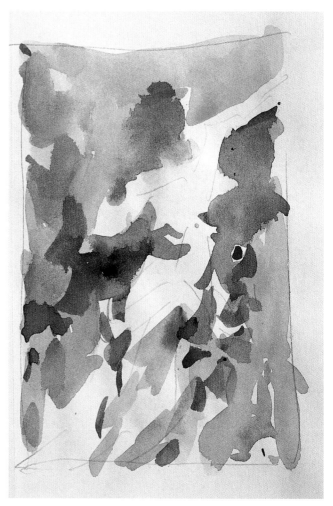

I remembered the impulse that gave birth to this painting. I wished for a bold, colorful, and wide-sweeping treatment of this pose. The time allotted was fifteen minutes. I established the head first to give scale to everything else. I shoved the figure to one side so I'd have plenty of room to splash in the colors. I finished ahead of time, and was tempted to add a few strokes to clarify to figure. In the end I decided to leave it alone.

The still-visible pencil lines demonstrate how far my explorations in abstraction were taking me from the original drawing.

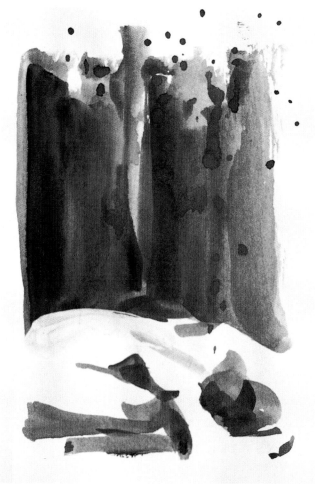

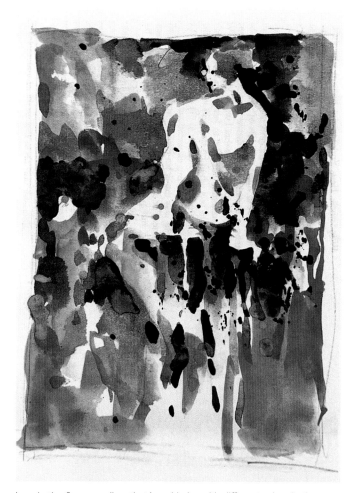

At this stage I was often tangled up in the intricacies of abstractions, so working with simple but dramatic divisions of space and contrast of color was always a welcome break. Some lines and tones were purposely left out to make the figure, crouching at the bottom, less obvious.

I made the figure small so that I could play with different colors in the larger surrounding area. The color scheme was basically warm, punctuated with a little green and a touch of mauve around the head. The dark reddish brown color helped to define the body. It jumped around in the background and was met with a large amount of raw sienna at the bottom. To create a harmonious composition I repeated the raw sienna at the upper left.

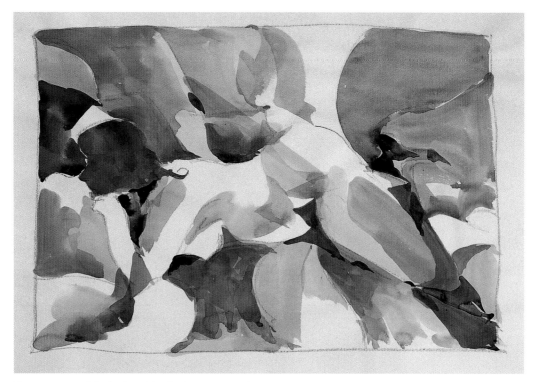

The curvature of the body and its shadows prompted me to use curved shapes for the rest of the painting. Notice the dark blue shape that started at the model's head. It moved up and down across her body, outlining her thigh, and moved off the painting at the lower right.

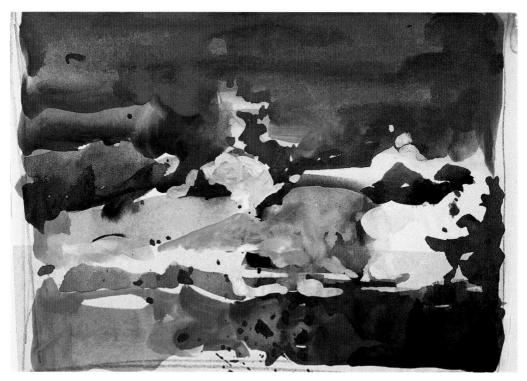

I placed the reclining figure in the bottom third of the painting to divide the horizontal composition unevenly. The dark violet at the lower right hardened to define the face, while the rest of the figure was left obscure, giving it a lost-and-found effect.

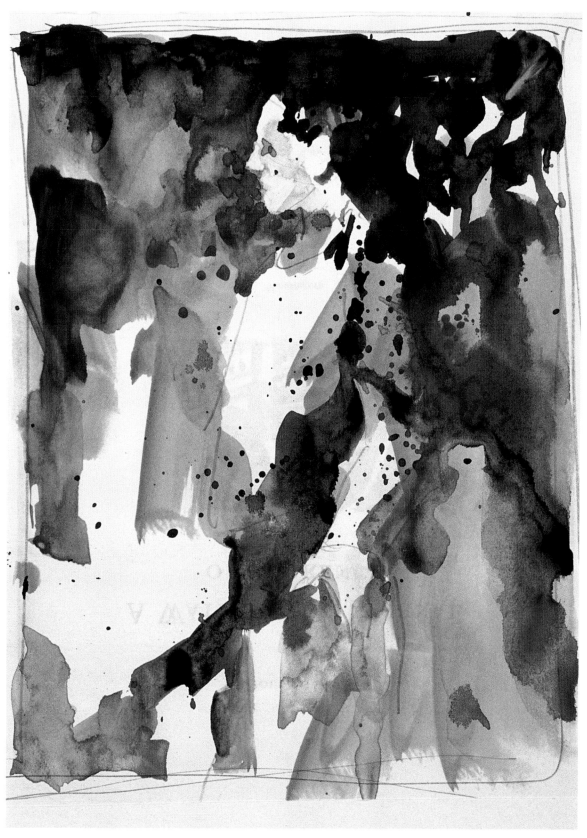

I let these strong colors intermingle in both soft and hard edges, but left white to show the face and the arm of the figure. I was careful to leave additional white areas outside the figure to add contrast and to balance the composition.

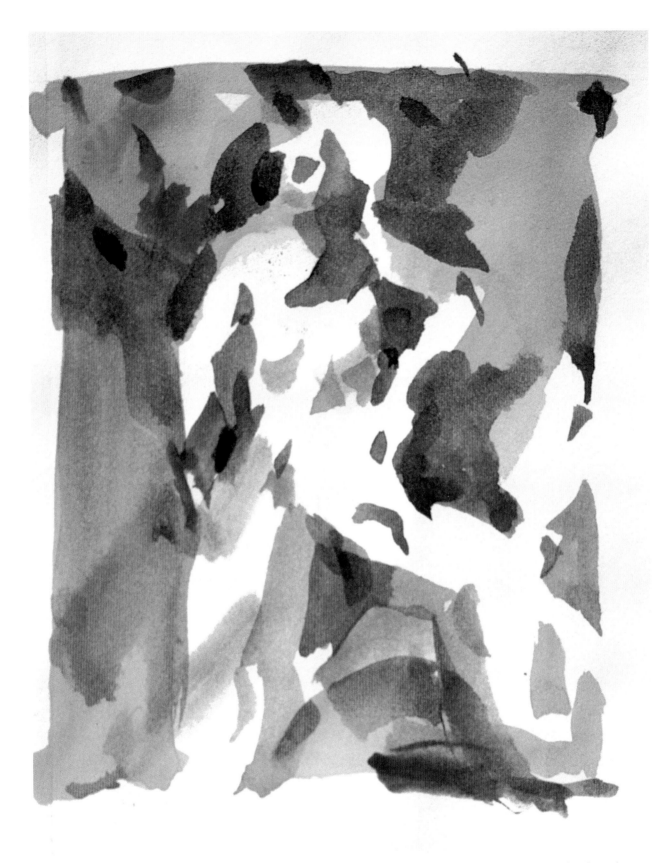

The staccato feeling of this painting was carried off largely with the choppy strokes that not only outline the figure, but also distort it to make an interesting presentation.

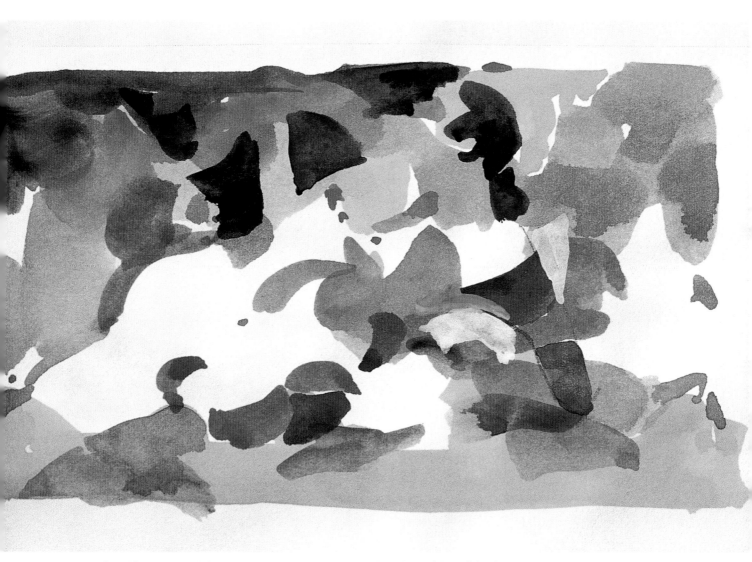

I used flat and curved shapes to weave an interesting pattern in and out of the reclining figure.

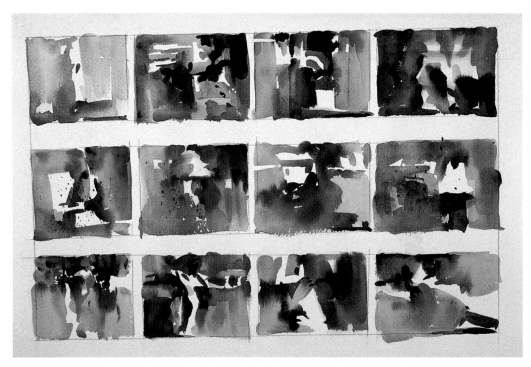

At about this stage of the development I did these thumbnail exercises at home to practice pushing my abstractions ever further.

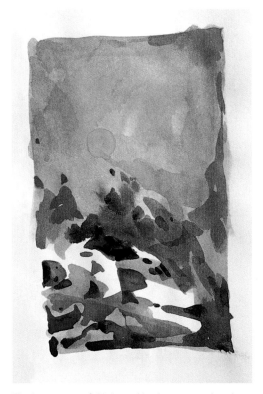

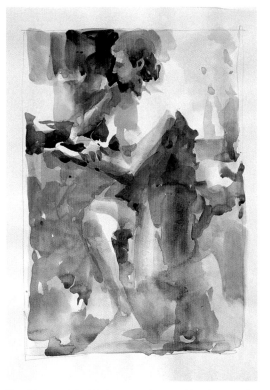

The lower part of this jagged landscape was already painted previously in a sketchbook of Italy. It had a faint suggestion of a figure, and that gave me the idea of picking a line drawing of a reclining figure that fit well in the landscape. I redid a very light pencil guideline before I started to paint.

For this pose I decided to experiment with using mostly soft edges right from the start. Despite large areas of wet intermingling, the drawing paper held up very well. The watercolor puddled and hardened in a few places, but that really didn't matter. I thought the lost edges at the shoulder and left leg added a sort of charming vagueness.

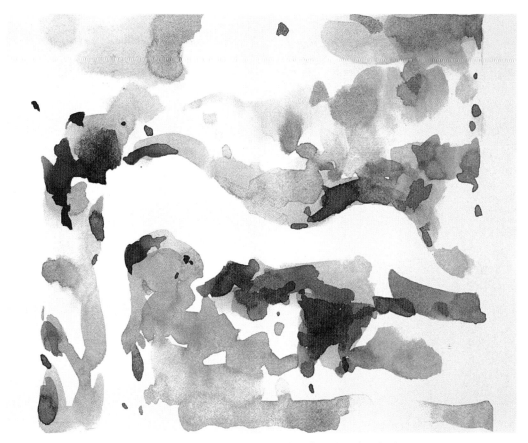

In this high-key treatment the reclining figure rests and floats amid soft shades of cool colors.

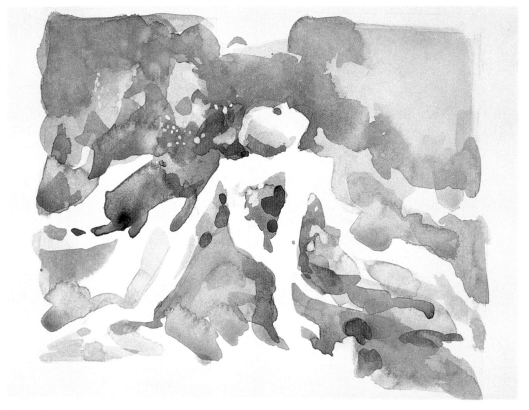

The cool colors and the wavelike strokes summed up simultaneously the impression of whitecaps on the sea and a sunbathing figure.

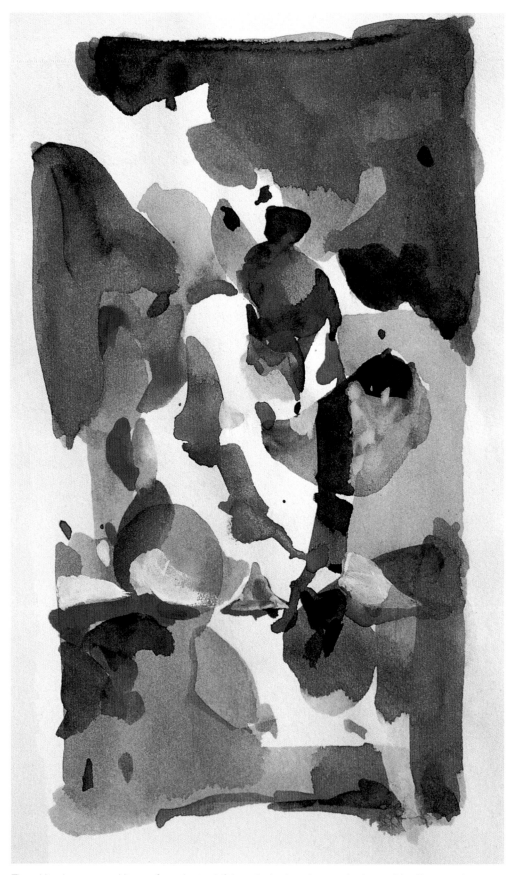

The white shape weaved its way from the top left, into the body, and out at the lower right. Once you locate the head or the crossed arms the figure emerges.

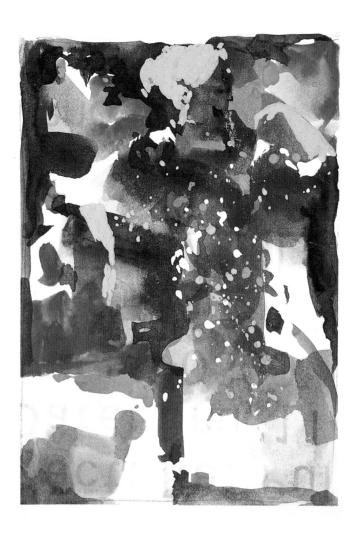

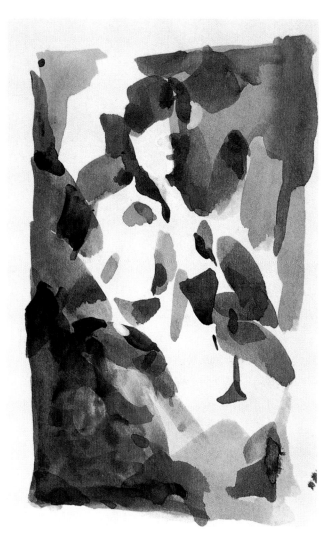

The texture of the model's dress was created with spattering. The hair and two arms were put in last in a tan-orange color to clarify an otherwise unrecognizable figure.

This monotone sketch offers a good example of the use of value alone to create an effective composition. Despite the lack of color, the value distribution was interesting and solid enough so I could now concentrate on colors—any colors, as long as I followed the value as a guide.

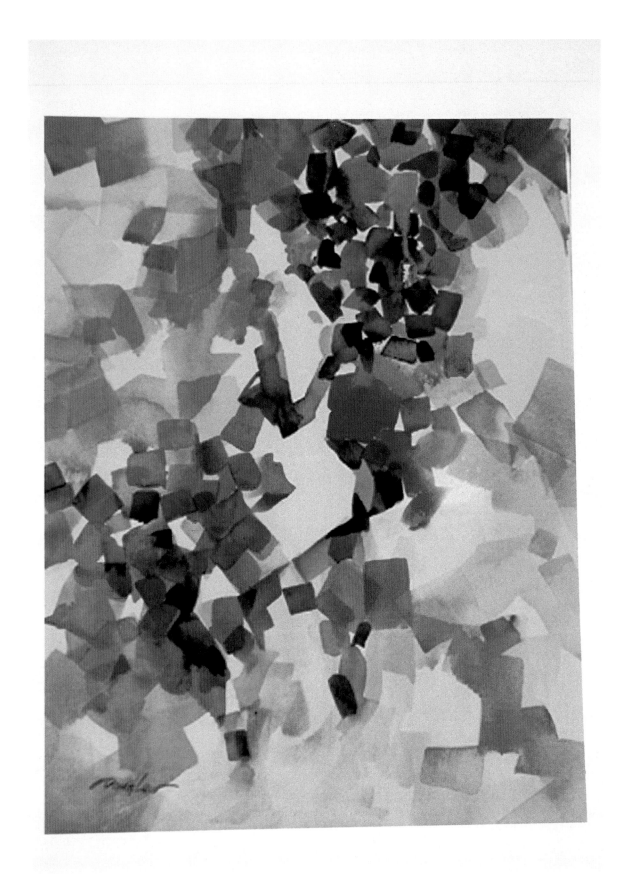

The juxtaposition of these square shapes—large ones against small, dark against light, neutral against intense—was instrumental in this work. I arranged the squares and colors in a visually exciting way that also led to a lost-and-found effect on the figure.

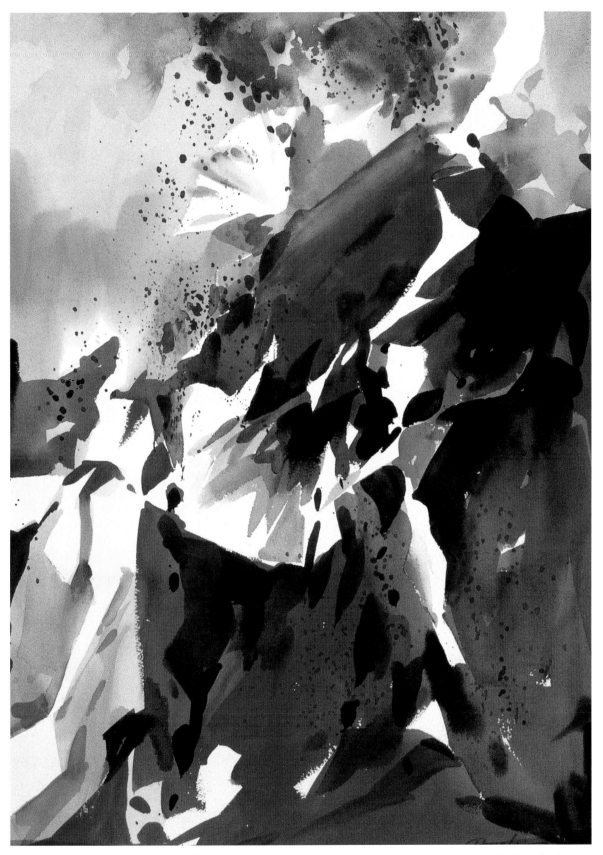

This finished painting is the culmination of the experiments I did over approximately two years as I moved steadily toward an increasingly abstract treatment of the figure.

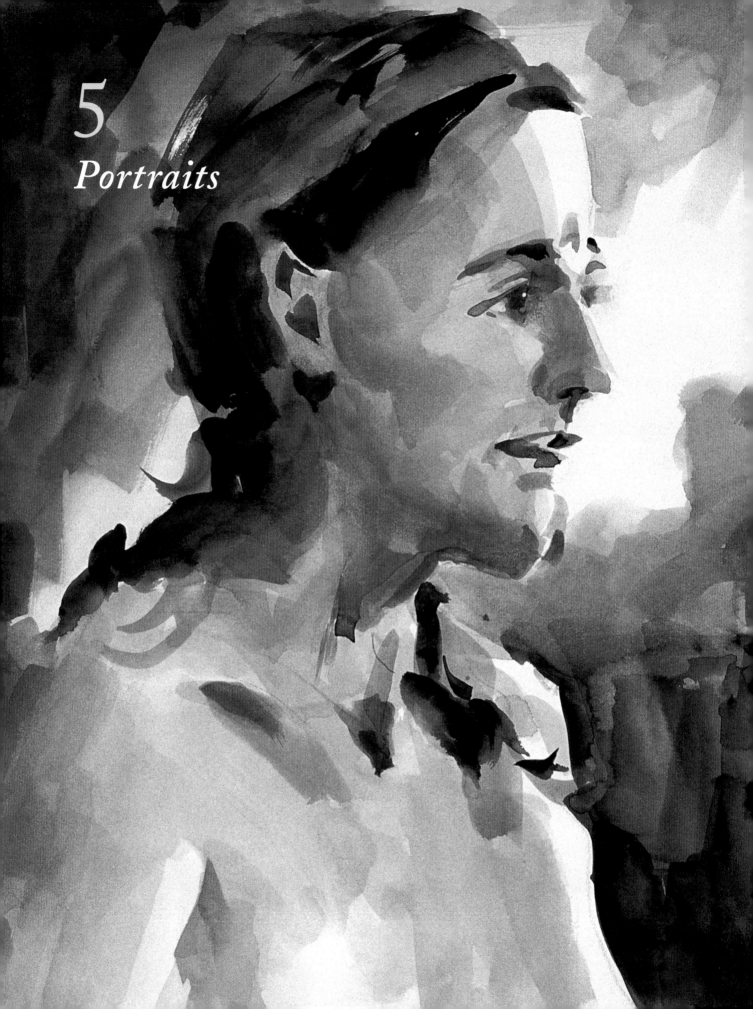

5

Portraits

Portraiture has always intrigued me. *There are millions and millions of people on this earth, and though they all have the same number of features on their faces, no two are alike! Portraiture is naturally linked to the figure. In a physical sense, it is a part of and an extension of figure painting. Just as the figure offers infinite views of the body, the face also offers a myriad of expressions. The primary difference lies in capturing the likeness of the person, as opposed to capturing the gesture of the body.*

Once in a while, I go to other co-ops devoted to portraiture where single poses are as long as two-and-one-half hours. During these long poses some artists jump back and forth between doing a fully clothed figure and simply concentrating on the face. The models are usually friends and acquaintances of the artists, and they are often a bit self-conscious. They can hold still, but understandably their faces become expressionless during a long pose. It's difficult to hold a laugh or smile, a tilt of the eyebrow, or a hand gesture for very long; and in a co-op it's not always possible to ask the model to hold a certain kind of expression or gesture just for your personal desire. If the model becomes stiff, a faithful rendering of the sitter may result in an accurate likeness, but most likely it will be lifeless. The answer to this problem is to search hard for clues that will reveal the sitter's inner personality.

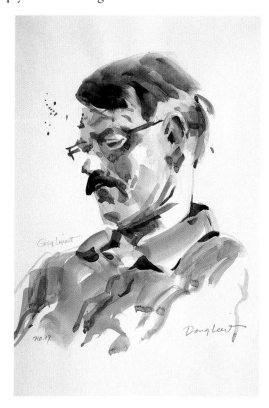

On the few days when models fail to show up the artists take turns posing for one another, usually for about twenty minutes. This is Greg. He is a good artist, and is the friend who introduced me to the co-op.

The Secret of Likeness

The secret? I like to think of it in two parts. The first is measuring. Is the structure of the face long, square, oval, triangular, or round? Is the placement of the eyes, nose, mouth, and ears correct? What's the distance between the eyes as compared to the width of the face? Are the eyes deeply set or are they more on the surface of the face? What's the length of the nose as compared to the length of the head, or to the width of the mouth, or to the distance between the nose and lips, and so on? If the measurements are correct, half of the battle is won. It really isn't all that difficult. Most experienced artists can do a fairly good job if given enough time, and most can do all the measuring by eye.

After the correct proportion is achieved, the second part of the secret is to render the shape of the individual features of the face—eyes, eyebrows, nose, mouth, and ears. This phase can seldom be done in a hurry as it takes careful observation to get the shape just right. Are the eyebrows thick and close to the eyes? Are the eyes wide set or close, heavy- or thin-lidded? Is the nose slightly tilted or straight, or does it have a bump? Are the lips full or thin, their corners curled up or down, or are they straight? This phase turns the anonymous face into a particular person. Short poses are really not suited for doing portraits; there simply isn't enough time. Nonetheless, short poses do offer opportunities for quick sketches of different angles of the head—turned, tilted up or down—and getting the placement of the features right is a worthwhile exercise.

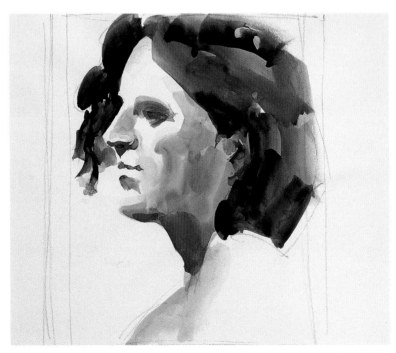

For this close-up sketch, I did a careful drawing of the profile with a single light pencil line. After determining where the ear was I felt confident enough to start with large strokes of watercolor. There wasn't enough time for additional detail, but I felt the measuring was correct, and the rest of the proportion fell in place.

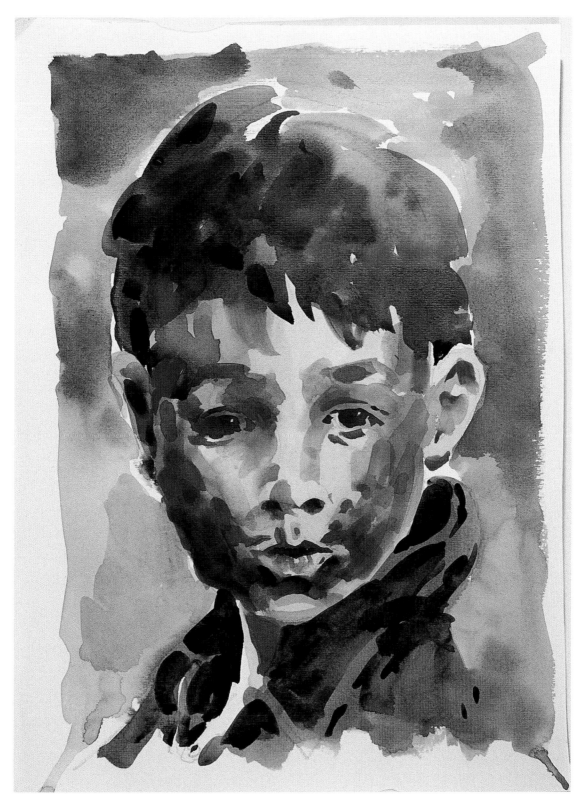

Of all the features on the face the mouth is probably the one that varies most from person to person. It can end in two dimples or two lines pointing down. The lips can vary in width, thickness, thinness, and unevenness. Aside from that, it's the most mobile part on the face. It can smile, laugh, curl up, curl down, stretch, contort, pucker, and move around in a circle. The second most distinguishing feature is the eyes. They differ in color, size, recession, and distance from each other (for example, some are close set; others are wide set). They can convey all shades of expressions: happiness, sadness, anger, concentration, doubt, frankness, suspicion, cynicism, and more. Age, of course, makes for easy differentiation in portrait depiction. Since children are so restless, I've painted most from photographs, except this one.

Likeness Versus Character

I've always been conscious of the difference between likeness and character. By character, I mean a particular expression or gesture that's typical of the person—proud or deprecating, happy or thoughtful, eager or wearied, anxious or bored, stiff or relaxed, defying or shy. It could be just a lifting of an eyebrow, a tilt of the chin, a look in the eyes, a raise of a shoulder, a gesture with the hands—in other words, an expression that reveals a deeper insight into the essence of the person. I've seen examples of some excellent likenesses by many good portrait painters that are void of character, but I also understand the difficulties in getting the sitter to pose in a manner that the artist thinks is typical of that person, especially if the sitter considers the pose unflattering.

At the co-op it's been helpful for me to observe the subject talking with other people during breaks; it is a good opportunity to look for expression clues. If you do a portrait of someone you already know you will be at an even greater advantage. That's why the most successful portraits are often informal ones and not commissioned. For that reason, when I'm outside the co-op, I don't hesitate to use a camera to capture those fleeting moments that will later help me

get more than just a surface likeness of a friend or neighbor. In a co-op, older faces are a better choice; they are more interesting to look at and to paint. Without any effort on the part of the model, his or her character is more apparent; all the lines tell so much—of years etched in living. Children are also wonderful subjects. They are generally not self-conscious, or if they are, their shyness and idiosyncracy may be part of their character. The trouble is, they can't always sit still; and the younger they are, the more likely they are to move.

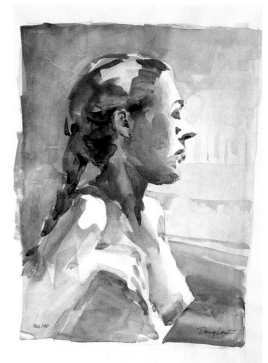

I tried this close-up of the same model, Roxanne, during a long, two-hour pose. I had done her whole body first (see page 75), and did this close-up in the same session. I caught the likeness and that's about all. I know Roxanne well and have hired her for my own workshops. For a portrait, I would pose her differently: perhaps in a chair, in a three-quarter view, and with her hands doing something with her hair or her ear.

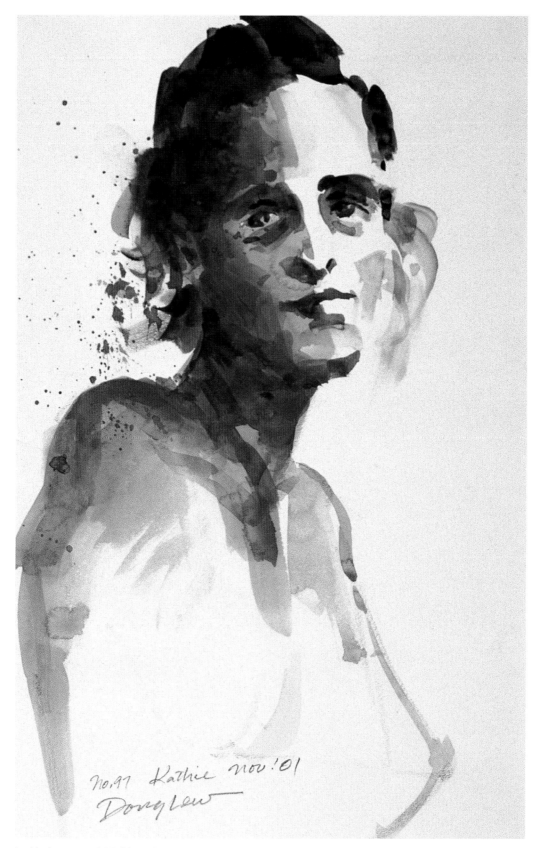

no.97 Kathie nov.'01
Doug Lew

In this short pose I felt I'd caught more than the surface likeness of the person, a rare occurrence in such a time constraint. I think the reason it was possible is that Kathie has been a regular model at the co-op, and most of us know her well. I always felt that her deep-set eyes had a thoughtful and slightly mournful look. I changed her head to a slight tilt to emphasize the look.

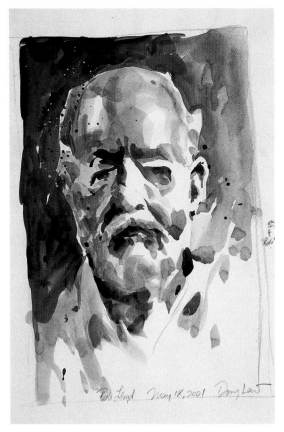

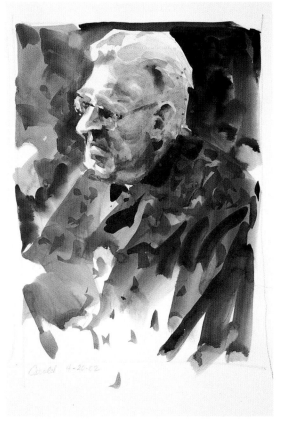

Eyes are the most difficult feature to capture. To stay alert portrait models usually move, or at minimum shift the direction of their gaze. I painted another portrait of this model in the same pose, yet the eyes look very different.

Carold is well over ninety and has just recently got rid of all his art equipment and moved into a nursing home. He has a full head of white hair. His Swedish is still good both in writing and reading. I loved the looks of this dear old man. Once I got the drawing down I found my brush gliding smoothly along the face, full of interesting character.

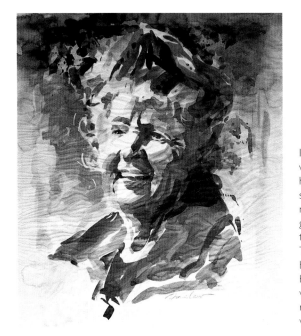

I painted this portrait of Genevieve from a photograph that was lent to me by an artist friend. Genevieve is an artist herself, and at ninety-five years old is still painting and going strong. I was struck by the openness of her smile, the gentleness of her eyes—her whole demeanor reflected the genuine happiness that is within her. I sat down and grabbed the nearest paper, and finished the painting in half an hour. The paper I'd grabbed was drawing paper. It wrinkled on me, but I just kept going because I wanted to quickly put down her expression while my first reaction was still fresh. In a way, it speaks of myself—I spend a lot of time in studying and reflecting on situations but react to them quickly—in art as well as in life.

Where Drawing Ends and Painting Begins

In the co-op, I can easily spend twenty minutes just drawing the likeness of the face, getting all the features right. That's not possible if I want to paint. Through experience, for a twenty-minute session, I attempt to limit the drawing time to about six to nine minutes, keeping the lines light with a soft pencil as I try to get the placement and shape of the features as accurate as possible. When nine minutes are up I begin to paint, regardless of whether I got everything just right. As I start to paint I find that I have a second chance to correct an inaccurate drawing. The problem could be the distance between the nose and the lips, or the setting of the ears might be too low or too high. I simply paint over the lines and correct the mistake. On short poses, I put down the slightest of outlines, and sometimes none at all, and start to paint. This practice made me realize the truth of this quote from Paul Cézanne (1839–1906): "Drawing and color are by no means two different things. As you paint, you draw. . . . When color is at its richest, the form is at its fullest."

I think Cézanne means that drawing itself is the preparation and the anticipation of painting: It's a process of finding essential lines to put down or omitting them to allow paint to do its work. Painting gives form and volume to a subject, yet this is also a function of drawing. During the act of painting I can correct drawing mistakes, or alter my drawing for other considerations, such as composition. The two work simultaneously and conjunctively.

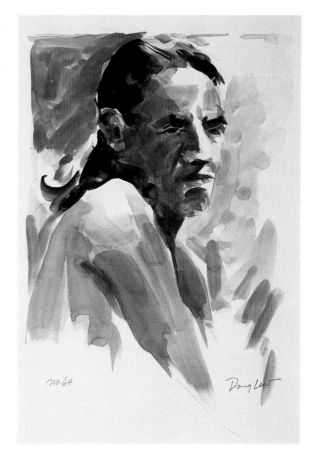

no.64

How often do you get a chance to paint a full-blooded Mayan in Minnesota? I knew I had to do the face of Octavio that afternoon, so I waited until his face turned toward me. Note the greenish cast to his hair. Smooth black hair usually reflects the light that falls upon it. In this case, daylight (blue) was mixed with artificial light (yellow), resulting in a greenish cast. Often we fool ourselves by painting what we know rather than painting what we see; such is the truth in painting.

INDEX